To Miriam

Preface

No one knows why they write a book, and this is not even trying to be one.
Put it this way, at times one feels the need to put certain memories in order, to clarify ideas, understand a story, a person, a past.
Or maybe, writing serves to remedy certain mistakes you've made, to make sense of an inadequacy that weighs on you, to justify certain stances taken, that in the end, have left you with a sense of guilt.
This is from the writer's point of view, then there are the readers.
These people are level-headed, curious and want to know certain things, certain particulars of a person's life.
This story is about my father, from when he was born to when he died.
But it is not just his story, it is the history of a country and of a world that is changing.
This book is about a great many people, relatives, friends and colleagues of my father.
If I had to tell you what it has done for me I wouldn't know how to reply.
I hope it does something for you.

Chapter 1 – Birth

Sebastiano returned home, pulling the heavy bicycle behind him, with its iron bike rack holding the hessian sack and the ropes for tying.
Sometimes smallholder farmers paid in kind with wine, eggs, chickens, which had to be brought home without spoiling anything.
He lived on the castle, up high, almost at the top of the Via della Chiesa. The last part he did on foot, so steep that not even Brusoni, the greatest cyclist of the time, would have been able to do it by bike.
It had been a hard, hot day, but he was happy, he had done good business in the last few days and then his friend's cow had given birth to a good calf, healthy and lively.
He might sell it next year, maybe in San Miniato or maybe closer, time will tell.
This is what Sebastiano Londi, the Montelupo cattle trader, was thinking while he loosened the collar of his shirt.
He was puny, almost minute but he was an elegant man and took pride in the way he dressed.
He liked to feel tidy and didn't suffer much from the heat; under his jacket he wore a shirt, tie and waistcoat, his shoes were polished and he wore his inseparable panama.
He was used to the beating sun, the dusty country roads and hot farmyards. In his job, one had to disregard bad weather and heat. He had to go and that was it, he had to go and make a good impression to earn trust and his daily bread.
He entered the courtyard where the small house that he lived in with his wife Marianna was located.
They had married the year before, and he smiled at the memory of that day when he told his father Giuseppe, known a Gali or Garibardi (in Montelupo dialect) with its mispronounced

consonant.
– *Father with your permission I'm going to marry Marianna from the Arrighi family, the ones of the wine-growing farm.*
He addressed him formally, in the manner of the times, and knew already that his father would have given him his blessing, despite a certain attitude that wasn't exactly emancipated.
The saying *"If you take a wife and you are well matched, you could do no worse"* was commonplace.
He leant the bicycle outside the door, dusted his jacket and trousers carefully, took off his hat and went in.
In the kitchen there were two women who stopped talking and looked at him seriously.
No smell of soup, a strange silence and the two neighbours who were looking at him curiously.
He was about to take off his jacket when the older woman spoke.
– *You can't go into your room 'Bastiano, Marianna is in labour.*
He said nothing, took a chair and went out into the courtyard to feel the cool air that had begun to arrive from the Pesa river below.
It was going to be a long night, he was to become a father.
He had two names in mind, Alma for a girl, Aldo for a boy.
It was almost dark when a woman came out of the house and looked at him smiling.
– *You can go in now 'Bastiano, it's a boy.*
Sebastiano got up and tidied his shirt collar, he wanted to look good for his wife and first-born son.
It was the fourth of August 1911, Sebastiano was 25, Marianna just 20.
He went into the house, his heart beating and the tears choking him, all he could manage to say was this:
Aldo Londi
It had a good sound to it.
Yes, Aldo Londi, was a good name, and it would be heard quite a bit in this small town, and then outside of here, in the world, for

many years to come, right up to the present day.

The story of this child born that evening is the story we want to tell. Son of a cattle trader and a housewife, as in those days women didn't work or even vote, they wore head scarves, as is the fashion today in certain countries.

The world has changed greatly since then, even that small town of Montelupo.

This change can be attributed, in part, to that particular baby, Aldo Londi.

This is his story.

Chapter 2 – The town and townsfolk

As we said, the year was 1911, over a century ago.
Let's try to imagine the world back then, or at least the country, the environment, and the historic moment.
Italy was celebrating its 50th Anniversary of Unity, the first Women's day, - on the 8th of March, in Belfast the Titanic was launched with great pomp and ceremony, the world's most beautiful liner, and the English were starting to build New Delhi to make it the new Indian capital in place of Calcutta.
And then there was the war with Turkey.
In those days, there was one every so often but it wouldn't have been described as a tragedy.
But strangely enough, this remote battle somewhat overlooked by the history books, was declared the same year that Aldo was born, and was fought in Tripolitania and Cyrenaica.
It was dubbed the "Libya Campaign", and took place in the Tobruk and Benghazi areas, places that were to have an enormous impact on the life of that child.
But let's go back to *Castello* in Montelupo.
It was a turn-of-the-century town and consisted of a high area, known as the *Castello* (or castle), and the lower area, to the back, which had been built up along the Pesa river and the railway.
Back then it had a few thousand inhabitants and was not a strictly rural town.
That said, the area was fertile, notably the flood plains of the Arno and the Pesa brought good harvests and the surrounding hills produced good wine (from the Marquis Antinori's estate, for example) and excellent olive oil.
But Montelupo had been a ceramic-producing town for many centuries.
Its site on the river, the abundance of woods surrounding it, and good and easily available sources of clay had made it a long-standing manufacturing hub where, during the previous century,

"factories" had begun to spring up. These were places where things were produced *en masse*, complex structures where tens or hundreds of people were organised in a manufacturing process committed to mechanised efficiency.

Montelupo produced ceramics and glass, notably the straw clad containers, especially flasks and demijohns for wine.

It also had its own trading system, without which the products could not be sold.

It was a hard-working town bursting with goods and people, workshops, furnaces and small factories surrounded by fertile fields and large cultivated hills.

There was lots of traffic, with horse-drawn carts laden with flasks and jugs, tankards, plates and crockery. Then there were carts pulled by oxen, laden with baskets of wheat, fruit and vegetables and, during harvest time, the crates full of grapes to be transported to the winery or the bales of olives on their way to the mill.

There were few cars, and even trucks were rare, despite the fact that the town was cut through its centre by the Tosco Romagnola State Road 67, the road that joined Pisa to Florence and then continued to Forlì through the Muraglione pass.

The State Road 67 was a kind of Italian Route 66, that linked the Tyrrhenian sea to the Adriatic, "coast to coast" as we would say now.

Montelupo was a town like many others, of farmers, factory workers and traders but with its own unique character.

The people of Montelupo were talkative. They cherished the *veglie*, or balmy summer evenings when they would sit outside for hours in the farmyards or on the doorstep of their home, always pulling out their "seggiola" (chair with a straw-woven seat), to take in the fresh air and chat among women.

But even the men enjoyed meeting up in the bars (there were several) to play card games such as *briscola* or *tresette*, or *biliardo*.

Sebastiano Londi was a good *biliardo* player; his speciality was

biliardo goriziana or 'nine-pin billiards'. He was practically a champion and he never missed out on a cigar and a good game if possible.

Both among the men inside the bars and the women sitting outside during the *veglie*, it was normal to hear witty one-liners, wise or sarcastic comments and the mutual moaning about known or presumed faults.

The folk of Montelupo were artists at this, always ready for a verbal duel, where the winner was not the one who shouted loudest or demonstrated the most aggression, nor the person with the strongest argument, but the person who, with persuasion, metaphor and gags, was able to make the crowd laugh, ridiculing the chance adversary.

No one called him Sebastiano, or even Londi, he was known as 'Bastiano, or by his nick name Chiodo [literally: Nail], that would then become the family nickname.

We don't exactly know the reason, but it may stem from a commonly used term in billiards, as he liked to leave his opponent in difficulty by hiding his ball behind the mass of nine-pins, making it difficult for his ball to be pocketed: known as *mettere il chiodo*.

- You see! Now I've put the nail in it!

It seems that he used to say this, hence the name, but it is not certain.

It was customary in Montelupo that almost all the families should have an additional name.

Not the individuals, but the families.

Chiodo, Cucco, Batone, Gotti, Celle, Falame were the nicknames given to a lineage. It is more than likely, therefore, that on that fourth of August one would have heard this kind of conversation from the windows of the houses of the Castello:

- Hey, did you hear that Marianna 'Bastiano's wife has had a son?
- So what did they call him?
- They've called him Ardo [vernacular for Aldo] di Chiodo.

Hence, there was a name, the suffix of where you came from, followed by the family name, a parochial badge that you dragged behind you for life.

Chapter 3 – Childhood

We know nothing about the early days of the new family but we can see Marianna, being aided by her neighbours and relatives, learning to wash, change and nurse her baby.
We can also imagine Sebastiano, travelling through countryside on his way to see farmers for that pig or calf.
- *'Bastiano, you've got a littlun now, here, take a couple of eggs and give them to Marianna to drink, they're good for her milk.*
Sebastiano would wrap them in hessian and went off again on his bicycle, looking out for stones and potholes.
- *A couple of eggs for my little Aldo.*
The are no records of Aldo's early childhood, as can be expected.
It must be remembered that this was a small town where the work was hard, life was fairly difficult and the goal was to bring home dinner, and dinner meant bread, cabbage lentils and little else.
The workload was heavy and hours were long, including Saturdays and Sundays. It was heavy tiring toil and working life started young.
In fact, you were lucky to reach the right age for work.
Back then there was not much preventive medicine for children, infant mortality was high, families numerous and the fact that people lived basically on top of each other certainly didn't favour a healthy, risk-free life.
One must also remember that those were the year of the World War I, a ugly event that involved many men, adults, youths and even boys and, although it didn't affect Montelupo directly, hundreds of people were sent to fight at the front, many of whom never returned home.
In those days without doubt, many children were brought into the world, and the Londi's were no different.
Aldo was three when his sister Alma arrived, five when Aroldo

was born and nine at the birth of Alfio.

It seems that Sebastiano was fond of the first letter of the alphabet, and of making love with his Marianna.

Therefore, in 1920 they already numbered 6 in the house and the business of feeding all those mouths must have been complicated for the poor man.

Maybe, thanks to his dealings with the farmers and butchers, every so often he would be given half a chicken, a rabbit or *conigliolo* as they say in Tuscany, or a piece of boiled beef, but it was certainly not a life of luxury.

Even so, the family enjoyed some moments of leisure when Sebastiano, an elegant and carefully-dressed man for the times he lived in, took the children to Montecatini together with their cousins, or even to Viareggio.

We assume that the trips to Viareggio would have been in train, while those to Montecatini would have been in a carriage, to "take the waters" in the Tettuccio thermal bath establishment, driven by a certain Fiorini, known as "Il Trallero", a Montelupo coachman who had a horse drawn trap for short distances and a covered Berlin carriage to transport a large number of people and for use in bad weather.

These were not grand holidays, just one-day outings, but carefree, fun and exciting, especially the days at the seaside where the people of Montelupo went only rarely in that era, as they were more accustomed to bathing in the nearby Pesa and Arno rivers.

Maybe Montecatini was in reality more for Sebastiano, he may have played some billiard tournaments there, as he also did in Florence and Empoli.

Whatever the reason, as a father he was always happy to take along that serious child, with those black eyelashes and dark, vivacious eyes.

A child who liked to watch everything, a careful observer and fast learner.

Sometimes he went with his father to the farmers and butchers,

maybe Sebastiano wanted to show him his job, to teach him so that one day Aldo would be able to take his place.

He would put the dark skinny lad on the bicycle bar, with rudimentary padding made from a piece of sack cloth and rope, and set off for the countryside.

Even his father Giuseppe was a "cattle trader" as was his grandfather Giovacchino, and he remembered, as a small boy, when it was his turn to ride the bicycle bar and go about and learn the trade.

Yes, Sebastiano was the third generation of Londi's to work as a dealer, and he proudly imagined, as he pedalled along, that he was carrying the fourth.

Destiny had a different plan for his child, but he was already teaching him another trade; how to be a man.

A trader, or more precisely a negotiator.

It consisted in bringing together two opposite points of view, and making them understand that there is a point in the negotiation where there is a reciprocal advantage, and showing this in a calm manner, using the right words and with the politeness of someone who respects the work of others.

It means empathising, understanding and knowing who is talking to you, paying attention and transforming things, making them possible, acceptable, sellable or purchasable depending on the situation.

Aldo was very young, but he was attentive and understood. He understood that his father made great efforts to get people to reach an agreement, but at the end, when the deal was sealed by spitting in the palm of their hand and shaking hands, he would see him smile under his moustache (all the Londi's had always sported a moustache) and raise his hat a moment to cool his head (slick with brilliantine and beads of sweat) before shaking hands too, guaranteeing the deal.

Hence, his job was made of words and deeds, but it was the words, good intentions, peaceful relations with everyone and the

showing of trust in order to earn it that counted in concluding the deeds.

Because at the end, it all comes down to a smile and a handshake, spit on the palm of both hands that join, to make a deal where everyone gains, gets ahead and lives a little better.

Aldo learnt the lesson well, that you have to know how to get on with people, because in life you never know who, or what you may need.

Chapter 4 – First school then ceramics

He probably had his first encounter with ceramics when he was still a child.
More than likely while playing he would have found some broken pottery, a material that was everywhere in Montelupo.
Over many years, centuries we could say, of kilns and kiln firers, wrong, broken and badly fired pieces ended up being used to fill gaps in the earth in courtyards and on the shores of the Pesa, to even out the roads, which at that time were not asphalted and the field lanes, and to fill the holes made by puddles, or were simply thrown away.
Children would have certainly played with them, looked at them, skimmed them over the water in place of flat skipping stones that are usually found on riverbeds.
It was a sort of natural imprinting, that creates confidence in a material otherwise unknown, that accustoms you to the shapes, colours and patterns that are part of your landscape.
However, there are many ways of seeing things. You can even become so accustomed to them and consider them so normal that you get to a point where you may not even notice them anymore.
But it was a different matter for those curious eyes that observed everything with attention.
Exploring those objects, looking at their colours and patterns in an effort to satisfy the curiosity that sprang from those eyes that wanted to dig deeper.
A child doesn't realise it, but everything is a lesson, even play, and little Aldo was taking a very special course in aesthetics without being aware of it.
He also had to learn to read and write and attended the primary school at Montelupo, where he was taught by the honourable Master Lami, an upright and severe man who also introduced to

Aldo a sense of honesty and justice. A man whose moral integrity would cost him his life in a Nazi concentration camp.

However, Aldo had a what was considered a serious defect in that era: he was left-handed.

Today it would be normal, no-one notices if someone writes with their left hand, but back then there was a duty to correct pupils using a coercive and somewhat brutal method.

The left arm was tied behind the child's back with a piece of cloth or cord, forcing him to use the right hand.

Maria Montessori may have had something to say about it, but the method always worked. Seeing as they used pen and ink pot it saved the sleeves on the school pinafore of any child who would have written left handed, as it prevented them from soiling their sleeve with the ink.

With Aldo, the method was partially successful; Maestro Lami made him perfectly ambidextrous, able to use both hands equally.

He may not have realised it then, but he did that child a great service. Those hands that were small but completely able to move, write, draw, paint, create and work, were to become a fortune for him and the things he did.

But, as we have said, those were hard times, as soon as one could, especially in large families, you had to contribute to the household and earn your keep.

Chapter 5 – Work

In fact, after completing his compulsory schooling, eleven-year-old Aldo was sent off to work.
Or more likely, he went by his own free will as it was the custom in those days to start as children.
Although there is no evidence, we imagine him as a serious boy, dark skinned, with the blackest curly hair and a sharp eye.
We don't have many pictures of his childhood as during that era having your photograph taken was a luxury that only a few people could afford.
Going to work was, therefore, a duty, a responsibility, an obligation towards the large family and Aldo did not shrink from this rule, he went off to the factory.
To tell the truth, proper factories were few and far between in those days.
There were small pottery works, made up of a few people, where the work was even harder, if possible, and the risks of an accident or contracting some illness were high.
Then there were the proper factories and, back then, there was a choice of three; Mancioli, Fanciullacci and Bitossi.
We don't know why, but Aldo went to Fanciullacci, which was the biggest manufacturer in Montelupo.
Maybe it was the nearest to his home, together with Bacchiole (the above said Mancioli), or maybe Sebastiano already knew someone there he trusted, and who took the boy on.
At Fanciullacci, in that era, workers were numerous, maybe more than a hundred, including painters, kiln workers, deliverymen and office staff. It was housed in a large building between Viale Umberto Primo and the Pesa, made up of enormous rooms full of shelves and work stations and crammed with products ready to be fired, painted or shipped.
This child - because he was in fact only a boy - timid, quiet and

maybe a little afraid, but cheerful and sociable, entered this factory.

Up until then his experiences had been school, where he had not only been taught to read and write, but also moral values and a very rigid sense of justice, in addition to the very strict upbringing he had received at home from his mother and father.

He had a peaceful childhood, made of games and small tasks, like fetching water, seeing as no one on the Castello had it in the house so it had to be fetched in the copper *mezzina* [pitcher] from the fountain down in the small piazza (now Piazza Centi), or else he helped his mother to carry back the laundry after it had been washed in the Pesa river.

Then there were the games with the other children, simple things as there were no toys, wo they had to make do with some pieces of wood and stones from the Pesa for a rudimentary game of 'lippa', or perhaps an argument that led to fisticuffs, which has always been popular among boys of all eras.

However, at eleven all this disappeared, you went to work, you grew up.

To our minds today, it seems crazy and unheard of. We wage battles so that Indian children are no longer employed to sew footballs, but back then it was normal even for us.

One also needs to understand the Montelupo trait for joking, for pranks that could also be a bit nasty, for perfidious teasing, for criticisms used to create amusement, which, in the factory environment was amplified, enlarged upon and at times pushed to the limits.

Chapter 6 – Aldo in the factory

- Careful Aldo, because as you well-know, people are ignorant, but if you do your bit, you'll be respected for it.
This is what his parents had to say to him in the first few days of work, as they watched him leave home.
- Chiodino [diminutive of the nickname Chiodo], *can you drop by Liserani's to fetch a pitcher of running water?*
This may have been the first order he received when he entered the factory, followed by everyone laughing.
That's how it is, the factory is a place for grown-ups, first they measure you up, they have to find out who you are and what you are like to understand what they should do with you.
The bullying of young recruits is a fairly rough method but effective for finding out what you are made of.
It involves stratas of hierarchy and a line of command, an essential thing in a factory especially one as large as Fanciullacci was at that time.
We are talking about a production of the highest quality, with a huge sample range specialising in reproductions.
Albissola, Deruta, Faenza, Vietri and Caltagirone; the shapes and decorations that made Italian ceramics so renowned over the centuries were entirely understood at Fanciullacci.
This was possibly because many years before, the Fanciullacci family had been directors of Richard Ginori in Sesto Fiorentino where the technology of ceramic production (and pigmentation) had been carefully studied for years.
At that time, however, Fanciullacci could be considered the University of Ceramics, at least for Montelupo and the surrounding area.
As such, the artists were the professors, the upper class that dictated the laws within the factory.
If you were at the top, you earned well.

Those who painted "finely", those who used the slenderest brushes, who worked in the *Raphaelesque* style, who designed garlands bursting with flowers and leaves with a flick of the wrist, they were top notch, the elite who perfectly expressed artistry and value within Fanciullacci.

Value, of course, because the management had a precise indicator: money.

If you made important and costly pieces, and you did them well, you got more money.

Much more.

All of which, gave you undisputed authority in the workplace.

Thus, the factory was a perfect mirror of society, a place where values and contradictions, dialectic clashes (even in the literal sense) and teamwork were pushed to the limits of their expression.

In the midst of all of this organised uproar, there was a child, Aldo Londi.

Fear, curiosity, a sense of inferiority, excitement at the prospect of a challenge; the heart is too small to contain all the emotions that you may feel faced with a similar test.

One can't talk of a lack of conscience: even at that age, we imagine him to be a very serious-minded, responsible person, albeit extremely curious and keen to understand.

Yet those first few days, or months, of his new life gave that boy with black curls, an imprint, a radical change and the aim for his entire existence.

It wasn't to be a job, but a love affair.

And like all love affairs, it would be all-consuming, all-pervading, unconditional and also, one might say, required.

Yes, Aldo fell in love with ceramics, and ceramics loved him back, and this love affair was to last over eighty years.

A lifetime.

We hardly know anything about this period, or at least nothing about the child worker, but we are sure he was lively, curious,

intelligent, attentive and quick to learn.
He had character but was not aggressive, he respected the rules and hierarchy and quickly made friends.
We believe that from the start, he knew how to handle people, he was a smart and educated boy who knew how to make himself liked.
He also knew how to make himself useful.
I think we can imagine how he acquired his cheerful capacity for banter that could raise a smile even at the worst of times.
Chiodino was never short of something to say and knew how to talk and make people laugh. The more this ability came to the fore, the more he felt he could bring people closer, convince them and make things easier which were sometimes anything but easy.
It was a skill that, possibly, his father had passed on to him, a skill he had learnt during the continuous business discussions between butchers and farmers.
He was learning the art of persuasion using words which, together with the persuasive value of facts, was to become very useful to him in life in general.
Aldo had character as well as a certain pig-headedness, a sense of respect for others but also for himself, and he never let anyone tread on him, no matter who they were.

Chapter 7 – Artists, friendships and family

Overall, he had a mixture of talents and defects that would distinguish him and possibly created for him a few problems, but have certainly helped him along the way.
He spent the best part of ten hours every day in the factory, and without doubt, apart from any boyhood friendships, he must have struck up new relationships within that world, with some of the expert workers who would have taken a liking to him and given him advice on how find his way around the difficulties of the work environment.
He was a lively boy, he watched everything with curiosity and learnt quickly.
He understood that if he wanted to achieve something worthwhile, he had to spend time among artists to learn the techniques, learn to distinguish between the decorations, the right paintbrushes and the right colours.
They were the rudimentary basis of an aesthetic culture that would have involved him much more than he could ever have imagined.
The work was hard, he had very little time to admire or reflect, but just imagine the wonder of a boy who sees a completely white plate that starts to come alive with figures and twirls and garlands and flowers and leaves, drawn by a hand that has such balance, with such harmonious gestures and such graceful movement that comes from the turn of the wrist, allowing the point of the brush to make a precise, clean, unwavering stroke, which, when the decoration is finished, coloured and glazed will make that plate a great piece of craftsmanship, if not of artistry.
That young boy, mesmerised as he watches the artist at his wheel, thinking *one day it will be me doing that stuff there*.
- *Chiodino, stop day-dreaming! Bring me a jug of water, I'm dying of thirst!*
The scene would have been something like this in the factory.
We don't know if it was within or outside of the factory that Aldo

met Bruno.

Bruno Bagnoli was a boy with freckles and a great thatch of curly, red hair, with a slightly shambling gait and three years younger.

In appearance, they seemed totally different, one a redhead with fair skin, the other with dark brown hair and dark skin, yet inside they were the same, and they became friends.

Aldo and Bruno simply understood each other: they had the same dreams, they were curious about the same things and shared the desire to discover the world and they were excited by the same trade, they wanted to become ceramicists.

Moreover, Bruno had an advantage, he continued school, he was keen to learn, did research and came back full of enthusiasm. He told his friend about Paris and the artists who lived there, about the world outside that was way beyond the *Raphaelesque* style.

They dreamed together, excited by their imagination and the few images that they managed to find. Then they decided:

- *We are going to Paris.*

It was probably 1925, the year in which the *Exposition internationale des Arts Décoratifs et industriels modernes* opened, that was to have a huge influence on the world, and in which Art Déco was born.

This story of the escape of our two friends towards Paris really happened, there are various records about it, but frankly we are unsure of the date, as in 1925 Aldo was 14 and Bruno only 11!

However, the trip to Paris of the two boys was shorter than planned and halted at customs in Ventimiglia.

The two boys were sent back to their town of departure and returned sadly to Montelupo, but who knows what would have happened if the pair had succeeded in their attempt.

Bruno attended the *Istituto d'Arte* of Porta Romana in Florence from 1927 to 1931, and obtained a diploma in the workers' course while continuing to work in the factories at Montelupo, first as an apprentice, then as a caster.

Another great friend of Aldo's in the trade was to be Benvenuto Staderini, also a young artist and equally determined, together

with Bruno and Aldo, to make art his livelihood.
Then there was Beppe Serafini, but he came along later, much later.
On the whole, for boys who were sensitive, willing, curious and capable, being born in Montelupo had its advantages.
And then there was friendship.
For Aldo, friends were a vital element, he really cared for his friends and his relationships were solid and long-lasting.
With Bruno Bagnoli and Beppe Serafini, for example, he remained in touch all his life, he remained friends with both and met them frequently, except for a period during the war or other unavoidable events, up to their deaths, after which he would remember them with affection.
In short, he had to work hard, but as luck had it, it was with shapes, colours and paint brushes, really stimulating activities that even today would fill many children with joy.
These were the days when you grew up quickly: you got yourself a job, you earned money and strived to keep the family going.
Meanwhile, in 1926, with the births of Alma and Giovanna, the Londi family had reached the standard family format of mother, father and six children, three boys and three girls.
In a family of eight, you were bound to grow up fast, but anyone who tried could find their own space, their own world and their own personal way of growing up.
In a family of eight, not only did you have to bring home money for food, but then you had to help your parents with the chores, help look after the little ones, "minding" the most recently born while mother went to the Pesa to wash the laundry.
Aldo took this matter of the responsibility of the first-born very seriously and, from the beginning, towards his brothers and sisters he acted like a third parent, even in an authoritarian manner but always with affection and an absolute sense of family.
Inside that Fanciullacci factory, Aldo grew, in years, in stature and knowledge and while he was still young, he became an apprentice

artist. Being talented, the apprenticeship was soon over and he earned his own work station full of colours, with his own brushes, potter's wheel and the typically low, straw-woven chair used by artists.

From then on, no-one considered him a boy any more, and when you grow, the time comes when you are ready for battle.

Chapter 8 – Military service

In 1932, he was called up for military service. Aldo enrolled in the army and left for Bologna, and was then posted to Zara on the Dalmatian coast (today Zadar in Croatia), that together with Lagosta had been an Italian province since the end of the World War I.
In Zara, Aldo explored, drew sketches, and sent letters home; for those days it was a kind of holiday.
He was a peaceful chap, friendly, jovial, quick to joke and banter.
This meant that, together with his respect for his superiors, he was well-liked by all and it earned him, if not privileges, at least a certain amount of freedom.
He returned to Italy and to Fanciullacci to continue in his trade.
- *If this is military service, I'm happy*, he would have thought to himself on returning to his family, his house, town and factory.
Although unknown to him, the years to come had many other surprises in store for him.
In 1935, at the age of twenty-four, once again he donned the uniform of the "Gavinina" division and in March he embarked the Colombo at the port of Naples, headed towards Massawa, Eritrea.
It was his first true "voyage", on board a ship, towards the unknown, the world outside.
Zara was Italian, very close to our shores. Massawa was in Africa and for a young provincial lad, although intelligent and ambitious, it must have been thrilling.
In fact, he wrote enthusiastic letters to his family in which he described the departure from Naples as a celebration involving the locals, the port and the entire city.
It was a long voyage, but it felt like a cruise to him.
Aldo was one of life's enthusiasts, his nature led him to see the positive side of things, in brief, the "search for beauty" was not

limited to aesthetics but reached further beyond, allowing him to find growth, professional and personal advantage, and to accumulate a wealth of experience, which even through hardship, became his "treasure".

He didn't know it yet but this optimism would serve him well on many occasions.

But for now, he was travelling on a large ship amidst a large number of peers. Immediately he made friends with the Tuscans, those who spoke his language, in particular Tonino Mori and a certain Walter.

Let's not forget at that time Italian was not that widely spoken, people spoke their own dialects and often they were unable to understand one another.

And he wrote, he wrote frequently and well, with his direct, pragmatic style in his manner of describing events and involving his family in the things that happened to him.

He always used a reassuring, calm and often jocular tone, as well as an effective technique: he wrote on all the usable surfaces of the writing paper, literally filling it with his fancy handwriting. He also used the outside of the envelope for a "parallel correspondence" with his friend Ganino, Montelupo's postman, who would write all the hot goings-on in town on the envelopes of letters abroad, and Aldo would then reply with his own news and that of other townsfolk with which he was in contact.

In each letter, whether addressed to his mother, father or to grandparents or relatives, there was a phrase, a quip, a motto that marked him out as wit and a shrewd thinker.

One for all: "... *the more time I have, the less of it I have to spare*".

This wit and shrewdness strengthened the relationships he established with his comrades and with his superiors, who were always pleased to enjoy some laughs with this good, willing and cheerful Tuscan chap.

In brief, Aldo knew how to make himself liked: he was a true *toscanaccio* (Tuscan), sharp-witted and cheerful with a good

disposition and kind to others.

On the 15th of that month, they made a stopover in Messina to embark more troops, then set off towards the Suez canal and cruised all the way down the Red Sea until they reached Massawa.

After 4,000 kilometres of sailing, Aldo's "cruise" enthusiasm may have worn off.

We only have fragmentary, imprecise news of this period, thanks to the letters and stories that have survived.

We know that in June he was in the town of Debarwa, which was around one hundred kilometres by road from the port of Massawa.

It was situated on a high plateau, at around two thousand meters above sea level, the nights were cool and the daytime temperatures were not torrid like those found in Adwa on the Red Sea.

He was healthy, he wrote, sketched and painted in any way and place possible, and luckily he was never involved in dangerous actions, despite working hard in his battalion.

He would then boast for the rest of his life that despite the many wars he took part in, he never shot a single round of ammunition.

He was a very committed to his work, his family, friendship, art and to his homeland: war was not something he could love.

A young provincial Tuscan catapulted into Abyssinia, full of enthusiasm for life, sure of his values and in the search for beautiful things.

He was already an artist, self-aware and keen to put his potential to the test, and there is no doubt that finding himself in such an exotic place would have fascinated him.

Eritrea is an ancient land, filled with history, art, traditions and culture.

It is believed that the first Christian communities settled there, spreading from Palestine with the Apostles. Even today, the Ethiopian Orthodox Church draws millions of worshippers into thousands of ancient churches filled with relics and Gospel

manuscripts. It is said that one church in Axum (town of the famous obelisk that Mussolini brought to Rome) safeguards the Ark of the Covenant.

However, it should be remembered that life in a military camp does not allow much possibility for tourism, visits to churches or excursions and then there was a distance between white occupiers and the blacks in the place occupied, which made any relationship difficult, but it seems that Aldo managed to make friends with Askari and locals, thanks maybe to his cheerful, peaceful and generous demeanour.

With some, he was to forge strong friendships, such as with a certain Holdaf who was always at his side.

This is evident from a sentence he once wrote that was quite revolutionary at the time: "*Believe me, they are Italian and good people, better than us*".

What emerges from the letters Aldo wrote to his family in that period was, in fact, his good humour, part real due to his innate optimism and in part "acted" to keep those as home calm.

Let us not forget that Italy was nevertheless a country at war, and although the Civil Engineering corps was not actually a front line department, the cannon blasts and firing was also aimed at them.

But it was his way of doing things that allowed him to win his personal, somewhat unconscious battle against the real war.

With a few tools scavenged here and there and the carbon black from the kitchen saucepans, he "frescoed" the canteen of the officer of the 84th Battalion of the Debarwa Infantry, where he met Indro Montanelli from Fucecchio, at that time the chief press officer, who gave him the nickname "Il Pinturicchio".

Wherever Aldo went, he clubbed together with any fellow townsfolk he found or, at least with Tuscans, and formed friendships with them,

While he was in Africa in July 1935, Alma, the sister born after him, married Giuseppe Masoni.

You can imagine the joy and the suffering of a man so attached to

his family at the discovery of an event of this importance while he is thousands of miles away from home.

In the years to come the war would deprive him of many other things, including around five stone in weight!

It would also keep him far from home for several years, and in reality this was just a taste of what was to come, although he didn't know it yet.

And he continued to write, to friends and relatives and he asks for them to write to him. In the spring of 1936 he sent Easter greeting telegrams to everyone including the Fanciullacci company.

In his last letter from Adwa, in September of 1936, being a single sheet folded into an envelope (the Airmail letter used at the time) on the small flap used to close the letter he found the space to send greetings to all the employees of the Montelupo Postal Service.

His friend Ganino certainly cut a fine figure.

Chapter 9 – The return from Abyssinia

Then finally, on the 9th of July in 1936 he returned home.
He saw the new family of his sister Alma and Giuseppe Masoni who live in Fibbiana and he returned to work at Fanciullacci.
Aldo was now a man, and a rather tall one for those times.
He stood 5'7" tall and weighed over eleven stone, he was slim but muscular, dark skinned with jet black wavy, almost curly hair and a moustache.
His time in Africa would have certainly given him an air of authority in a country where many had never even seen the sea and the contact with all those military comrades and the Askari and Abyssinians had made him worldlier, surer of himself and even more charming and sociable, conscious that wit, jokes and a cheerful spirit build more bridges between people than the whole Civil Engineering corps of the Italian army put together.
In 1937 he made a trip to Venice with Vincenzo Ossani, his friend and "master artist" at Fanciullacci, possibly to see an exhibition about Tintoretto in Ca' Pesaro.
He learned that his sister Alma was expecting a child: we can imagine his joy at the news.
But he would have to put aside the joyful prospect of becoming an uncle as in late 1939 he was called up once again by his country and is sent to Ventimiglia as a border guard.
At that time, the borders between states were a serious matter, watched over by armies: Europe was nothing like it is today and wars were sparked off by very little.
Even here, the first thing he did was to search out others from Montelupo, in his effort to solve the problems of communication with the families back home he made many new friendships.
He loved getting to know people and his curiosity and his sociability overcame many barriers, a part of his character that stayed with him for life.
Meanwhile, at home, Pietro Masoni was born and he was only to

see him when he took leave together with his friend, Antonio Mori. They really earned this period of leave with a great deal of hard work as both were veterans of the war in Abyssinia.

At last, on 15 December of 1939, the permanent leave they had so much desired was granted.

Aldo spent Christmas at home, hoping it would be the first of many.

It was not to be, however, as only a few months later, after taking part in the *Prelittoriali del Lavoro* (a sort of competition during the Fascist period) in the ceramics sector, in which he came third, he was once more called to arms and had to put on his uniform. Italy was again at war in 1940 - this time it was the big one, World War II.

Chapter 10 – World War II

He was sent to Tobruk, in Cyrenaica (Libya), where he practically already spent Christmas of 1940, which cannot have been a calm one.
Tobruk was a very important port for the whole of North Africa and had been part of Italian Libya since 1912, thanks to the Libyan War that Italy won against the Ottomans in 1911.
Now, that Colony that was born practically together with Aldo, grew to become fortified and unconquerable, with high city walls, armed with ramparts, machine guns and cannons and dotted with bunkers and blockhouses.
He was able to visit it, not quite comfortably, 29 years after its construction, and he could not have chosen a worse time.
He did not choose it, however: he was just a simple soldier who had to defend himself, along with his fellow soldiers from the mighty British army.
In Tobruk he just spent Christmas, because in January 1941 the city was conquered by the 8th British Army, that made them all prisoners.
One day, they heard the tanks approaching and came out of the bunker with their hands held up. Aldo handed over to a British soldier his rifle, that he had never used, and declared his name, surname, register number and rank to the officer who took it.
On January 21 for him the war was over. After such a long time, marches and sentry duties his military career had not taken a step forward, he was still a simple soldier.
He had not shot anyone, and that gun was the only weapon that his hands ever gripped.
Since then, only brushes.
We are convinced that he felt relieved, but the worst was yet to come.
The war was tough, but captivity, if possible, is even worse.

There were thousands, tens of thousands of people who had to be transferred to a safe place and meanwhile watched over, made harmless, and for as much as possible held kept alive, with minimum expenditure of energy, because in the meantime there was a war to fight.

The transfer itself, for example, certainly wasn't by bus, but was made on foot in very long columns, in forced marches, and if anyone lagged behind they would face the death penalty for no one could remain behind, under death penalty for insubordination.

The food, already scarce for regular troops, could certainly not be plenty for the prisoners.

One thing was learned right away, that is the word POW, an acronym that could be seen everywhere, on documents, permits, on every piece of paper that circulates inside the prison.

POW was the acronym of "prisoner of war", an acronym that would have marked Aldo and all of his companions in misfortune for a long time to come.

For the impassive English administration a POW was a number, a burden that should represent a minimum burden when a war is going on, an annoying obligation, to be fulfilled with the minimum effort.

Dust, heat, sun, little water, very little food, walking in a row along the tracks, blinded, dehydrated, injured, but still walking.

They had to take them to Egypt, which was under British control, where the prisoners wouldn't have hampered military operations, then send them to a faraway prison camp.

How far?

Perhaps the POWs did not know it, and perhaps they did not even know where they were being taken, but they had to walk anyway.

Their destination was Alexandria in Egypt, on the Nile Delta, more than 600 kilometres from Tobruk.

When you consider the heat, the desert, sand storms and other

inconveniences, how long does it take to cover over 600 kilometres on foot?

In the most optimistic forecast, more than a month, maybe a month and a half.

Luckily it was winter.

Once they had arrived in Alexandria in Egypt, and you can just imagine the state they were in and how many had died during the journey, they were embarked on a large ship called New Scotia.

It was as a vessel of about 7,000 tons built in 1926 as an ocean liner, which the British Navy had requisitioned for troop transport and rearranged as needed to bring, through the Suez Canal, the Red Sea and the Indian Ocean, prisoners of war, the above-mentioned POWs, to Durban in South Africa.

Similarly, the journey from Alexandria in Egypt to Durban was no cruise.

Over nine thousand kilometres over sea, being chased and hounded by German warships and submarines.

We don't know exactly how long this journey lasted, but it was hard, very hard, nothing could be more different from a cruise.

After leaving them in Durban, the New Scotia then returned to the Mediterranean, and in November 1942 it was in Massawa, for a new load of POWs to be brought to South Africa.

She never got there.

About 300 kilometres from its destination she was hit by the torpedoes of a German submarine, a U-Boot.

She sank, with 1,200 men on board, including 769 Italian prisoners.

The survivors numbered 181, 117 Italians, plus a total of 64 English and South Africans.

They were rescued by neutral Portuguese ships, which brought them to safety in areas that were not occupied by the British.

Many of them decided to remain in Maputo in Mozambique, they started to work, started a family and an Italian colony still lives there: a good colony with good values.

One thing must be said about Aldo: even in the huge tragedy of the war, he knew how to take the right ship at the right time, and his fortunate timing, his peculiar way of transforming disasters into an opportunity to resist, survive, and overcome adversity, would have accompanied him for the rest of his life.

Let's now go back to Durban, at the start of 1941, when the ship arrived at the port.

They got them off the ship, and maybe after a medical exam and a modest ration of food they were back on the march, this time heading towards Zonderwater, near Pretoria, 621 kilometres north-west.

Another walk of just over a month in the African heat, except that in the southern hemisphere they call winter summer.

Luckily, Aldo was fit. He was thirty and was still physically strong, despite the fact that for some time he had smoked like a chimney. In any case, the transfer to Zonderwater would be yet another harsh test for all, selective and fatal for several of them.

Chapter 11 – Imprisonment

Zonderwater (Boer for "without water") is a dot on the map of South Africa, a small village just a few kilometres from Cullinan, another godforsaken place 40 kilometres away from the city of Pretoria, currently the capital.

Cullinan became famous for its diamond mine, in which the homonymous stone was found, weighing more than 3,000 carats. Being nothing but a poor conglomeration of miners' houses, it took its name from Sir Thomas Cullinan, the mine owner.

In short, this was the centre of the African bush, characterized by implacable sun, few trees, no shade, plenty of tall grass, great mountains of debris extracted from the mine, a few houses and a concentration camp.

They called it an Internment Camp, but certainly names did not make any difference.

It consisted (once completed, maybe a long time after his arrival) of 14 camps, each able to "host" 8,000 men, and each divided into 4 blocks that could host up to 2,000 people.

There was also a transit camp and a sorting camp, and a structure for decontamination, to which a military hospital of 1,600 beds was added, at that time the largest hospital in South Africa.

It was a town invented by Englishmen in that plane, with 40 km of internal roads and all the essential services.

Too bad it was surrounded by fences, barbed wire, watch towers and armed men.

In other words, a concentration camp where Aldo would live, along with more than 100,000 other Italians, until the end of the war.

To be precise, his new address was "Geniere Aldo Londi, POW number 171949, Camp 13 Block 4, Zonderwater Block, Cullinan South Africa".

The early days were the hardest, the camp has not been set up

and was little more than a tent city. It was a matter of living outdoors during the day and sleeping rough at night, and apparently it was poorly managed, disorganised and, perhaps because of the uncertain destinies of the war in Africa the British were not at all kind to their prisoners.

After the events of Tobruk, he sent his first letter home on 30 July 1941, from South Africa. Several months had passed.

As always he reassured and comforted his family on his physical and mental health, urging her to take special care of the "little girls", as he called his sisters, then correcting himself to "girls", given the time that had passed since he had last seen them.

In the letters, of course, he omitted any mention of difficulties and deprivations, such as the fact that in the region that was then called Transvaal there were very heavy rains that flooded everything, and thunderstorms caused huge bolts of lightning to strike the ground, attracted by the hardware of the tents, killing the occupants.

Only when he had returned home, when he was spurred by the curiosity of his relatives, did he describe those moments when the iron rings of the tent poles were found on the ground, completely melted, small shiny spheres in the mud, alongside the bodies of his comrades, tiny, shrivelled and burned to a cinder by the lightning.

This way of relating from afar to the family was a constant, and betrayed not only his incredible homesickness, on the verge of despair, but his profound moral conviction, his scale of values that he never doubted and would always be a solid starting point for any aesthetic research, however extreme or courageous it may be.

He spoke of Alma not only as a sister but as a mother, and there was hardly a letter that did not contain a thought for her and her children.

Of the many letters in fact, nearly all were addressed to his mother Marianna, but he also wrote to Alma, recognising her as

part of her new family with "Beppino" (Giuseppe Masoni) and their children in addition to his original family.

This strong concept of family is an anchor, a moral pillar that would accompany him throughout his life, which led to him being recognised by all his relatives, his brothers and sisters but also his brother and sisters-in-law, nephews and nieces, as a patriarch, a pillar of the family to whom they could turn at any time, in good times and in bad.

Certainly when young Aldo had acquired his strict education, due to his parents but also to his very early work commitment. In adulthood, however, and perhaps with the war and captivity, he had built up a great a courageous rigour, a moral strength and kind yet strong character that did not allow him any anxieties or fear, only prudence if anything, and reasonableness, but without hesitation.

Zonderwater was practically under construction: the huts, roads and the buildings that would then house canteens, dormitories, kitchens, and surgeries still had to be built, as did anything required by a city where over one hundred thousand people lived, including English, Italian and South Africans.

To be precise, in his book "*One hundred Italian prisoners in South Africa. The Zonderwater camp*", Lorenzo Carlesso counted a total of 108,885 inhabitants spread over 14 districts, with 50 neighbourhoods, plus 30 kilometres of roads, 3,000 hospital beds, 17 theatres, 16 soccer fields, 6 tennis courts, 80 bowling courts, 7 fencing halls, volleyball and basketball courts, gyms and boxing rings.

However, Aldo at thirty, was a prisoner along with several of his comrades and friends, in a valley of South Africa, and had to invent a new life for himself.

This is where the real Londi came out, the man who turned his work, obligations and daily tasks into a research purpose and his reason for living.

Being a prisoner, and having to pass one's days with an amount

of food that was probably close to malnutrition, would have made most people fall into the state of starvation, which is typical of those who feel worthless, defeated and forgotten by everyone.

On the contrary, there was so much to do. A city had to be built, he had to improve his life conditions and assume an active role that would keep his mind and body busy for the time he would spend in that prison.

He also had to find himself a "position", not so much with his friends, fellow countrymen and the numerous people he had got to know in the camp, but with the new landlords, the English and the South Africans, who certainly didn't have a great like of the Italians at that time.

In fact it seems that in the first period of life in the camp, until 1942, colonels Rennie and De Wet did not succeed in establishing a good relationship with the prisoners, who were constantly digging tunnels to escape.

One of these tunnels reached the length of 90 meters and a depth of 11, and was dug secretly at night.

Then, in 1942, an inspection was carried out by a certain Doctor Diogo, from Brazil, who said that in Zonderwater, depression was dominant and that something had to be done: Colonel Hendrik Fredrik Prisloo was appointed commander, and the music changed.

Prisloo was a South African ally of the English, but as a young man he had been imprisoned by them, when they fought against the Boers, and he was very familiar with life in a prisoner-of-war camp.

First of all, a library was built to which 10,000 books were brought, followed by a large school.

A great many of the prisoners at the time were poor devils, farm workers without any education at all, but with the new school, illiteracy in the camp dropped from the initial 30% to 2%.

For a poor chap who had no other way of communicating with his folks back home, nine thousand kilometres away, the fact of

being able to read and to write was perhaps the greatest conquest imaginable.
In this mayhem of transformations, improvements and social evolution, Aldo threw himself in head-first and did what he was best at.
He painted.
He painted everything, embellishing canteens, walls, theatres, building backdrops, theatre wings, curtains, in brief, he really set to work, and worked hard.
That was it: work.
Work meant everything to him: it was his way of asserting himself as an individual, of acknowledging his value and himself as a free human being, even in the most shameful of conditions, imprisonment.
It was his objective to get up in the morning having something to do, or rather a lot to do.
He used every scrap of paper, rag, pencil or crayon, every piece of charcoal or other colouring material he could lay his hands on for making a drawing, a sketch, a piece of world as he saw it.
This is how he established relationships with its jailers, who appreciated his good will, enterprising spirit, the joy and the affability of that Tuscan chap with a moustache.
In particular, captain Sonnabend captain, with whom he would maintain a solid relationship of esteem.
There was a huge obstacle, however: the language.
These were Boers. Among themselves they spoke Afrikaans, a guttural language similar to Dutch, and they spoke to the prisoners only in English.
He had to learn it, and quickly.
Aldo made the greatest effort, collected notes and compiled a sort of pocket vocabulary book that he took with him everywhere. He spent his free time reading anything he could find, listening to this new language and trying to understand.
It would be his salvation, because he knew that once he had got

rid of the language barrier, he would be able to express himself, to offer to do things and ask free time, in other words to establish a direct relationship that would allow him to gain trust, ability to act and freedom of movement.

It took him time but he was on the ball and knew how to listen. He read, studied, took notes, learned vocabulary, gestures, expressions, and embarked on this new adventure, without fear and was confident he would obtain something.

Indeed he did just this. With the English and the South Africans, he established excellent relationships, which may not have been exactly fraternal friendships as those with his Italian companions of misfortune, at least had respect, esteem and trust confidence.

As he was so busy, his hands and brain were itching and he had to find something creative to occupy the time and earn manoeuvre space and a slice of freedom.

In fact English opened many doors for him, together with his cheerfulness and cordial affability that was highly appreciated.

He acted as interpreter, making life easier for just about everyone, for his fellow prisoners who were finally able to make themselves understood to the jailers, and by the jailers themselves, who could finally communicate with the prisoners without any misunderstandings.

This led to him befriending captain Sonnabend, mentioned above, who would allow him to paint inside the camp, to produce ceramics and do so even outside the fenced areas, in the nearby village of Compoutville where, with the aid of the locals, he built a domed kiln and started to produce pots and pans and various other utensils.

In brief, he was well liked by many, black, Boers, English and Italians, and his cheerful and benevolent manner allowed him to earn points, both in the and outside the camp.

These were precious, because in that very camp he was to spend five long years.

It's not even possible to imagine staying away from home five

years, the only contact being a letter from time to time, if your relatives felt like writing letters and the Regie Poste (or the Royal Mail) felt like forwarding them to you.

Basically, he was just in time to receive a small letter also from his nephew, Pietro, whom he had seen as a new-born baby shortly before setting off for the war.

In his letters, he did not reveal almost anything but merely sent his regards to all, to his mother, brothers and sisters, relatives, friends and acquaintances, and asked all of them to write, to do so more often and to invite others to write to him in that place so far away.

He was merely asking for human contact, to strengthen that very fragile piece of string that connects a prisoner far away from his home, to his family, friends, to his previous normal life as a busy person.

He never stopped clinging to that piece of string, and he also took it back home with him, but not before paying for sins he had not committed.

In one letter address to his family in November 1943, he wrote: *All my friends, from the oldest to the youngest, are with me here, I'm the scale of hope that never fails, the very symbol of cheerfulness.*

In another letter dated January 1943, he wrote: *I read, observe and paint, in my strong belief that also this is life".*

In the meantime, he would obtain clay and kilns for firing ceramics, pigments and paint brushes, he made pots and pans, he did charcoal sketches, water painting, pictures, theatre backdrops, he painted school rooms, theatres, canteens, post offices, and even found the time to build an enormous statue of San Francesco in concrete over a reinforced iron structure, which stood six metres tall in the main square of camp Zonderwater.

As there was an abundance of time, he left Zonderwater longer after the war ended, in the summer of 1946, when he again embarked on a ship in Durban. He made a stopover in Mombasa Kenya, in the second half of July, then in Port Suez and finally

Naples.

Chapter 12 – Homecoming

He finally returned to Montelupo on 14 Agosto 1946, his thirty-fifth birthday.
When he got off the train, it was noon. The church bells were ringing, the sun was high in the sky, and looking around him in the glaring light, he recognised his hometown.
Aldo Londi had turned 35, he was home and about to start a new life.
He had been away from home a total of six years, five of which spent in prison, away from his loved ones and normal life.
Six years is a long, long time, never-ending, and had cost him a huge amount of sacrifice.
In six years he saw a great number of people die, tens, hundreds of friends, fellow soldiers, fellow countrymen, thousands of young men.
When you are far away and suffer, you join forces, consolidate existing relationships and build up new friendships, because in that hell called war, you really learn to count your blessings.
In those moments, nobody pretends, fear and courage are real and sometimes become part of that sincere humanity that makes you immediately distinguish between bad and good people: you become attached to the good and come to rely on them greatly.
And then you see them to die, bombed or shot to death, you see them get ill and wither, eaten by unknown tropical illnesses, and you cling even more to the survivors: they become brothers, they become your family.
Then one day, you are told you are going home, and it all comes to an end.
Perhaps in that very moment, you look inside your soul and feel like a veteran.
You have survived something terrible and are lucky to be going back home, but you now find yourself lugging all those who will

never return home on your shoulders. You carry them in your heart.

Yes, perhaps that's the weight he felt as he went on board the ship bound for home.

He would certainly have thought about what he had left six years before, his home, the town, his family and friends, the factory and his work colleagues.

He knew he would have found everything changed. Montelupo, too, had witnessed the war, the front, the bombings and the gunshots.

He had around one month to think about it, as he was travelling back by ship. Time to think about what he had left so many years earlier, about what he was leaving now and what he would have found.

Unfortunately this is only a story, many of the people it told were no longer living and it was also a new era, so one has to use the imagination.

Just imagine, for example, on that 4th day of August 1946, at the railway station of Montelupo, where a door of that train with the wooden benches opened and a man got off.

He had left many years before, when he was still very young and full of hopes, desires and even ambitions. Born in a working class town with a rather provincial attitude, a country lad burning to understand the world and what was happening far away.

Now he was a man. He was exhausted and had lost a lot of weight and weighed less than 7 stone, which was very little for a man who stood 5'7" tall.

From the top of the station, he could look down on his town below.

Not even Montelupo was the same. Many houses had been destroyed by the bombs, the bridge not was no longer there, the streets were obstructed by debris and various broken objects.

That's what Aldo saw as he looked at his Montelupo on his thirty-fifth birthday.

The war had changed both of them.
But he was home, thin but healthy, exhausted but still intact in spite of the bullets, hunger, illnesses and all the incidents involved in a damned war that had stolen years of his life.
That is what it was: stolen life, years gone to waste because of a stupid, no, a cursed something that destroys everything and every person and destroys thousands of lives of soldiers, but above all the lives of normal people, defenceless old women and children.
No-one more than him would have hated war.
Then came the whirlwind.
He crossed through the town and went up to the Castello. Once again he saw his mother and father, his brothers and sisters, then all his cousins. Then came Ganino and his friends, until he was finally able to hold his nephew Pietro, and taste his mother's wholesome cooking at that table, in that room, in that house in that town he had dreamed about for such a long time.
Of the many birthdays that Londi had celebrated in his life, that was perhaps the best of all.
He was happy, he had been able to get to know his new brother-in-law, Beppino Masoni, Alma's husband, and also the wife-to-be of Aroldo, Giuseppina Prosperi, a truly good young woman from Empoli, the niece of the hotel owner, Maggino.
She would certainly have knocked some sense into that hot-headed brother of his.
He also met Marcello Bitossi, the fiancé of his youngest sister, Anna, who had been little more than a child when he left and had since become a beautiful woman.
He was back with his family once more, able to go out, look around and meet up with his friends.
Without forgetting Bruno Bagnoli, Benvenuto Staderini, Beppe Serafini, all his fellow artists he had left when they told him he had to put down his paint brush and embrace a rifle.
Some had died, either at war or in the air raids, or had been deported by the Nazis, like poor master Lami.

Yes, the world had changed, it was no longer the same. Everything around him had been destroyed and you could almost touch the emptiness.

He was a true optimist, however, and in one way or the other he was determined to fill that emptiness with new things just waiting to be invented, certainly better than what had been there before.

How could he have contributed?

Working, doing the trade that he knew and loved and had never stopped doing, not even in prison.

He wanted to produce ceramics once more.

He had to recover his strength, however, and that physical vigour that a veteran cannot find again in two days after six years of deprivation.

Perhaps because it was August, or perhaps because the factory, which was near the bridge and the railway, had been bombed, he did not go back to work at Fanciullacci immediately. Then September arrived and the date of his sister Anna's wedding, which had already been decided before he returned.

Naturally, she too married a ceramicist, Marcello Bitossi.

He was not a labourer, however, but an entrepreneur from a family of entrepreneurs, who directed and managed the company "Manifattura Ceramica Cav. Guido Bitossi e Figli" together with his siblings Mario Vittoriano and Carlo.

They were true entrepreneurs who, in spite of the war, had known how to take advantage of certain occasions well, and had a well-established factory: a ceramics factory.

According to a true story, with documents to prove it, during the passage of the front, it was very hard to procure clay, glazes and pigments.

Any truck that ventured out onto the roads ran a risk not only due to the holes left by the bombs and the debris, but also risked being machine-gunned by the plane of the allies, because it was still an enemy truck.

Indeed, not only were there hardly any trucks, no driver in those

days risked driving one because they put their own lives at risk.
That made work almost impossible, so one morning, as Vittoriano Bitossi stood outside the factory on the State Road 67 between Montelupo and Samminiatello, rather dejected and perhaps also very angry, a huge American car passed by, a camouflage-painted Buick, with green and brown blotches, full of soldiers. It passed by at great speed in a cloud of dust. Then, all of a sudden, it halted and reversed.
Some soldiers jumped down, went up to Vittoriano and asked him if his factory was open.
Vittoriano said yes, it was open and they were missing raw materials.
One can almost hear the reply of an American colonel or general.
- *For us it's no problem.*
These words were a sign of the power, the willingness and the capacity of the Americans at that time.
They put it into practice, too.
Days later the soldiers, who were part of the AFI (the American Force in Italy, who still live in Camp Derby on the Tuscan coast), came back to define a supply contract for the U.S. Army based in Italy.
It involved thousands, perhaps tens of thousands, in other words a huge amount of crockery.
Plates for the officials, but above all large coffee cups that they called mugs, because the Americans liked to drink coffee everywhere, even out on the battlefield.
Naturally, the mugs were suited to their type of coffee, much more diluted than the Italian *espresso*, with or without sugar or milk, but boiling hot. They poured out a full cup at a time, just like in the movies.
As for the raw materials, in the days that followed, a whole column of American trucks arrived, loaded with clay and glazes to produce ceramic tableware.
So the Bitossi brothers worked and made their labourers work,

too. They hired more labourers and replenished the family cash box once more.

This is one of the few pleasant stories that could be told of World War II.

On top of this, Anna and Marcello were about to be married and everyone at home was happy, including Aldo.

The Bitossi family were good people and hard workers. They were not conceited but almost shy and modest, in spite of their importance in Montelupo.

Marcello was a lean type, with a straight nose and a nasal voice. He was always dressed to the nines, with his hair combed back and shiny with brilliantine.

He hit it off with Aldo immediately. It was clear that they got on well, they had serious conversations about ceramics, like two professionals, but they also spoke about other things and you could often hear them laughing and joking.

Anna Londi and Marcello Bitossi were married on 12th October 1946, but it was not a great celebration, as the Bitossi brothers had lost their mother four months earlier, while their father Guido, the founder of the Company, had died in 1937.

At the end of the ceremony, when many of the guests had left, the groom took his new brother-in-law to one side and said to him, quite simply:

- Now I don't want you to even comment on it Chiodo, from tomorrow you're coming to work with me.

Chapter 13 – At Bitossi

Life was not exactly straightforward but has sudden changes of direction, abrupt changes that were not there one minute earlier but when they happen, you know something big is happening to you.
Since inheriting the company upon their father's death, the four brothers – but mainly Vittoriano and Marcello – had really worked hard, and thanks to the long distance that divided their factory from bridges and railways, they had never stopped working.
Even before the war, for example, they had profitable relationships with foreign clients, especially the Americans, because at the beginning of the twentieth century, the Americans had set up "buying Commissiaries", which would be today be referred to as a buying offices. Italian craftsmanship, especially Florentine craftsmanship, has in fact always fascinated the Anglo-Saxon world, especially the Americans.
After the war the Americans left, but the Germans were good customers, and in Montelupo ceramics were then produced for clients in Berlin or Hamburg or Hanover, rather than New York or Philadelphia.
In short, the Bitossi brothers never stopped; they were determined to produce ceramics but also more.
In fact in 1946, just as Aldo started to work in their factory of ceramics, they opened a paint factory.
The *Colorificio Ceramico della Robbia* began to produce clays, enamels and pigments for ceramic production.
And they got it right, because in a Country full of ruins that had to be totally rebuilt, there would be a great demand for building work: small and large houses, large buildings and skyscrapers, entire districts to rebuild or to invent, and millions of square meters of floor tiles to cover bathrooms and kitchens and the

floors inside homes. There was also a need for vases and bowls, flowerpot holders, umbrella holders and also tableware to put in the new cupboards.

The world in the post-war period was like a world waking up, full of desire to make up for all the suffering, to redeem the deprivations and to embrace a better lifestyle.

Bitossi knew or at least guessed this, and wanted to play a major part in this story.

Chiodo also had his own ideas, given the last six years he has spent in the war, five of which in jail.

He wanted to relax, to resume the life that belonged to him, to dedicate himself to the thing that appealed to him most: ceramics. Naturally there was also his family and all his loved ones, in addition to the new arrivals in the family – nephews and nieces – and his old friends, all of whom now appeared under a new light that gave things a different value from a veteran perspective.

Not a pessimistic one, however: just the opposite.

It was a thirsty way to look at the world, keen to know and to learn.

For him, let's remember it, the world was already small.

He had spent five years on the other side of the globe, he had learned new languages and customs and how to deal with and solve seemingly impossible difficulties.

He had won his own personal war, despite losing that of his Country, and nothing more would have defeated him.

He had created ceramics where the earth was red and barren and he had created art by painting empty bowls and falling-down shacks. Now he was close to his loved ones, at home, in the cradle of the Renaissance: the world was his oyster.

He had missed out on Artistic developments, and with the aid of painter and ceramist friends he recovered lost ground, visiting all the exhibitions and the museums he could, and was often found in the art galleries in Florence.

He also found the perfect travel companion in his brother-in-law

Marcello.

Of all the brothers, Marcello was the one in charge of the organizational and commercial side of the ceramics factory, so he was in close contact with his brother-in-law and both shared a very strong curiosity or a "thirst" for art that, with Aldo, was easy to quench.

Apart from their family tie, they happened to be friends, and enjoyed spending time together also on Sundays, not only during the working week.

This however did not spare Chiodo from a hard apprenticeship in the factory.

"Cav. Guido Bitossi and Figli" was a well lubricated and perfectly working machine, with its own hierarchies and its working methods.

They produced the classic local ceramics, and would have continued for a little longer, also with Aldo.

He was officially hired on January 20, 1947, with the qualification of "painter".

He would retire from work in 1976 as a "a second level technical employee" but actually continued to go to the factory right until his last day.

Maybe he has never left the factory, some think he is still there.

In short, Londi entered this factory slowly, on tiptoes, but with the desire to put himself to the test, to make ceramics with a different style, a new material, suited to the world evolving around him and to the way of life that was forming.

That's because when you get up in the morning, you have to feel what wind is blowing and what lies ahead, so you can prepare yourself for anything.

In this respect, the world around him also helped him to change.

Chapter 14 - The Americans

The Anglo-American Allies had won, and this was also an important fact.
He knew them well, they had been his "enemies" and jailers for five years, he had departed from them as friends and with a certain amount of emotion. He spoke their language perfectly. He was not an educated man but had read a great deal and had a polished, articulate way of speaking and knew how to converse with wit and intelligence. His wide vocabulary and command of both languages (Italian and English) were truly uncommon.
Aldo was also the son of Bastiano di Chiodo, the "mediator".
All of his father's skills, which he had learned at the cattle markets, in the cow sheds and on the farmyards would be useful to him when dealing with customers who came to buy ceramics from Bitossi.
Another thing would come in handy was his innate curiosity, his ability to learn new styles and adapt to human behaviour, especially new patterns of behaviour.
Furthermore in Italy there was now this culture of the winners from across the Atlantic who wanted products bearing the new "Made in Italy" label at all (or at least reasonable) costs.
The Bitossi brothers continued with their classic production however, in other words tableware with floral designs, and although Aldo was a fine ceramist, he was not yet in a position to enforce anything introduction, but only to start integrating it with a few ideas.
The paints factory was very useful, as he was able to take samples there and ask for new glazes, pigments, or transparent frits that allowed him to express his creativity and personal tastes.
In order to feel like a complete ceramist, it was not only necessary to have artistic skills as when he worked at Fanciullacci. At Bitossi, he needed to know the complete process and the techniques, to check all the various aspects that make up a shape, a design and a

surface.

Thanks to his commitment and dedication, he soon achieved the results he wanted.

The ceramic factory and the paint factory were next to each other, and Aldo was often seen going from one to another, coming back with small full of coloured powders that he put on his workbench, with a small label on the rim of the bowls containing notes.

He continued to churn out sketches and designs, which began to take on bizarre shapes, with bowls, vases and pitchers that resembled cats or strange birds, with their own distinct, unusual style.

In the meantime, he continued to search for inspiration by reading magazines and newspapers cutting out photographs and articles and making notes of everything he came across.

He also wrote a lot, although the scraps of paper containing his notes would often get lost already left in his trouser pockets and thus washed by his mother.

He was often engrossed in his thoughts but also eclectic, always cheerful yet suspicious at times, willing to joke but also to argue when necessary.

He also knew what you wanted, and was simply waiting for the right opportunity.

This opportunity came with the foreign buyers who arrived in Italy in the 1950s looking for interesting items to sell back home at interesting prices.

If, until then, Londi had been forced to pedal uphill, he now found himself on the plain, or rather a tandem, with the client pedalling on his side.

Nothing like it had ever happened before in Italy. Europe was still struggling (perhaps with the exception of the Nordic countries), but mainly in the United States the post war period sparked off a whole new way of thinking that went beyond euphoria.

After many years of war, freedom had won: not only political

freedom and the individual freedom of thought, however, but also freedom in aesthetic terms.
This euphoria has to entrance formed into something visible and something one could touch and see anywhere, something that told you the world had changed.
There were incredible novelties and innovations in literature, architecture and arts in general, but there was also a change that could involve common people and be understood by all.
This came about with the birth of the modern industrial society and consumerism: that idea of happiness that is generated by a decent, average lifestyle, perhaps mediocre but widespread and able to bring high earnings and ground-breaking new designs.
In other words, in Italy the Americans did not only finance the reconstruction of the country with the Marshall plan, but asked the Italians to share their vision, or rather to contribute to this change with their own ideas and products.
It was an exchange, of words and concepts at first, then of goods and money.
This did not scare Aldo, whose period of imprisonment had taught him just how small the world was. On the contrary, he pedalled harder in that direction.
He thus exploited the fact that foreign buyers where coming to speak directly with them in English. Not only did he understand their needs, but was able to translate them into shapes and colours, designs and textures, in other words Products that could be sold exported and purchased in prestigious stores around the world and would be perfect in German, American or Japanese homes.
These products told anyone who looked at them that the world has changed that freedom had won, and you were free to buy them for just a few dollars.
Over the decades, Aldo had learnt how to search for, study, predict, understand and discover beauty. He knew how to make it, also by making mistakes, how to talk and discuss with thousands

of people, how to maintain hundreds of friendships, and now he knew how to do his job.

He was a ceramist who replied to the demands made to him: in ceramic.

In 1948, he took part in the Universal Exhibition of Prisoners of War, organised by the Red Cross in Geneva, to which he sent the paintings, water colours and sketches he had done as a prisoner.

It also continued to paint, and certain friendships became even stronger, also those with his old work colleagues at Fanciullacci, such as Staderini and Serafini, and even more so with Bruno Bagnoli, the one he tried to go to Paris with.

Together with Bagnoli, in 1950 he organised an exhibition in Montelupo to which he took a lot of paintings and also ceramic items.

In December of that year he even managed to make that famous trip to Paris that had failed so many years earlier. It was organised by the Academy of fine arts of Florence, and Bruno, who still attended the Academy invited Aldo to join him.

A large number of people went – all painters – including Scatizzi and also Libertario Bertini, who was not a painter but was a friend of everyone in the group. Aldo was a great friend of Libertario, although they did not share the same political views.

Had a great respect for each other and when, during the fascist period, Bertini was exiled due to his political ideas (not surprisingly, as his surname was that of the Communist Party leader at the time), the only person who accompanied him to the station was young Aldo himself.

Although he was certainly no fan of communism he had learned to hate fascism and was very fond of Libertario.

In short, that grim period has come to an end: there was still a great deal to do to reconstruct the world and Montelupo wanted to do its part.

Like many people, Aldo had a great desire to forget the past, to start a new life made of hope and projects, to continue a new life

as a grown man and free himself of the ugliness of war, to construct a new civilisation of well-being and also the symbols that had to represent this new world.

There was a desire to laugh and enjoy life, to work and invent new, more modern shapes where art and industry merged to produce objects to furnish the new homes and buildings and the districts and skyscrapers in which people lived in the 1950s.

In short, Chiodo kept himself busy: he went to see all the exhibition he could, he visited art galleries and met many painters even famous painters such as Pietro Annigoni and Ottone Rosai, and then returned home to his family and to his factory to carry on with his job as ceramist.

He worked from eight to noon and from half past one to very late in the evening.

Chapter 15 – Aldo starts a family

With all the work he had to do, without counting his commitments with such a large family in which Aldo have now become the man of the house, there seemed to be little or no time left for romance.

Nothing is known about his courtships and love stories in his younger years. In spite of his good looks, Aldo was also a very serious minded person in certain situations, very attached to his family and exceptionally discreet. Although the newspaper entitled *vox populi* was very popular in Montelupo, nothing is known about his first approach with other sex.

Many of his friends were already married with children, so it was high time that Chiodo started a family of his own.

It is not even certain when he first met Iolanda Lelli. We know that she was from and old family of Montelupo, also a very large family, that before the war lived in via Paoletti in Florence, and that they all worked in the knitwear trade and that her mother, Emma, had a dressmaking milliner's shop at the end of the bridge, in the centre of the town.

In those years millowners made hats and veils, and that sort of thing for women, for their 'Sunday best'.

Most certainly the two families new each other, especially during the war when the Lelli family escaped from Florence after the bombings and took shelter as evacuees in *Poggio alle Donne*, a small hill next to *Erta*, which dominated Montelupo from the side opposite *Castello*.

The Lelli family was made up of father, mother, two sons and three very beautiful daughters.

The two families also shared a strict, catholic, rigorous upbringing, an honest work ethic and very strict moral values.

In short, after a brief courtship of which we know nothing, Aldo and Iolanda tied the knot on 1 October 1951 and went to live in the centre, in Corso Garibaldi, the road that leads from the bridge

over the Pesa river towards Samminiatello, and at that time formed part of the State Road 67 when it was brimming with bicycles and carts, cars and lorries.

They rented a small flat on the top floor above the *drogheria* (similar to a corner shop) run by Aldo Viviani and his wife Anna, who was Iolanda's older sister.

On the floor below them lived Marco Marconcini, a survey, who had just arrived from the area around Pisa, together with his new bride, who had also found themselves homeless.

Further below was the home of the Vivianis, while the shop of his in-laws on the ground floor sold a wide variety of goods, including coffee, sugar, umbrellas, hats, gloves, salt, pepper, sultanas, spices and others.

No-one had a car in those days: even the Vivianis took the train to go to the wholesalers in Genoa or Livorno to buy what they needed for their shop.

There was to be done in Montelupo, but no-one held back. Every morning without fail, the Vivianis would raise the shutters, Marconcini would layout his paintings on the table and Aldo would leave for the factory.

At the factory he was gaining importance in the sense that there were more and more of his creations in the standard collection and they also sold well.

He also took part in exhibitions and tradeshows such as the *Mostra dell'Artigianato* of Florence in 1952, 1953 and 1954, followed by exhibitions in Faenza, Vicenza, Sesto Fiorentino and Livorno.

Chapter 16 – Design and industry

Although the role of a designer was not yet clear, in that period, the ceramic sector was trying to industrialise and automate its processes, with items that could be mass produced by simple machinists without any particular skills with ceramics or painting.
This meant making it easy pieces that's required only few manual interventions, possibly moulded and coloured by dipping them into the pigment solution.
Otherwise it involved items with 'graffito' drawings, rather primitive and elementary, and the backgrounds were filled in using course paintbrushes, a bit like in a child's colouring book.
It wasn't easy. Just one silly mistake and the entire piece would appear broken, unfinished, boring and thus unsellable.
There was no end of fights with the Raphaelesque artists, the ones who painted even the tiniest details with their fine-tipped paintbrushes, earned well and made the most expensive items.
The industrial world was gaining more and more ground however of the old world of agriculture and craftsmanship.
Farmers wanted to stop working the soil: the work was too hard and always dependent on the weather. They also had to live in those huge farmhouses with no heating in the winter when they had to break the ice covering the tub just to wash themselves and, if the harvest had been bad, all they had to eat was soup with any greens they could find, a few beans and onions.
Whole families abandoned their work and homes in the country and flocked to the towns, where industry now required low-cost labourers.
They lived in council houses, or houses in very poor condition, but at least and could fetch running water in the nearby town square, without any risk that the world would dry up in summer.
They also had a low but steady wage. Their children could you reach school without having to walk for miles and miles and on

Saturday morning, if they had a few *Liras* to spare, they would go to the to buy some fruit and vegetables and – if they were lucky – half a hen to make some broth.
Fruit, vegetables and hens were sold by a few remaining farmers.
In the knowledge that these low-cost labourers, which you needed to increase production and meet the markets demands, how can a farmer – who had never made anything in ceramic – be turned into a ceramist in a short time?
It was no trivial thing to produce fine ceramic without expert painters or potters.
He was helped by his incredible practical sense.
He knew all about clays and colours, the various treatments and firing processes and for anything he did not know, he simply experimented, tried and learned, and took down notes in the dozens of diaries and notes flying around that only he was able to read.
He also created simple, modern shapes many of which could be produced using plaster moulds, and rustic textures and coverings. They were almost primitive that simple to make with almost childish graffitis and backgrounds that still had a very imaginative effect.
Stencils and rollers and other instruments were invented, some more pointed than others, to mark, engrave and imprint simple but powerful, graphic and modern decorations.
In this way, with workers without a great level of skill, it was possible to create highly attractive ceramic objects with a new formal style, which is now referred to as design.
Aldo, however, did not aim to produce art in his ceramics but wanted the ceramics to look good and be easy to sell.
Real recognition is not only participation in a trade show or exhibition. The rewards is an order, a satisfied customer who tells you that your products are selling like hot cakes, and going home happy because things are going well.
From a very young age Aldo did not distinguish between the

"departments" in his life. For him there was not his family and his private life on the one hand and work on the other. There was no separation between art and craftsmanship, between research and production or between prototypes and the items that made it to the collection.

He tended to mingle everything together and destroy any walls that separated customers from friendship or work from emotions, for example.

This is why he might go around an exhibition on a Sunday with his friend and brother-in-law Marcello Bitossi, or with the artist or potter with whom he worked six days a week, ten hours a day.

At times he might discuss and argue with a client about pricing and variants and an order until 8 o'clock at night, and then invite him to his home to dinner.

Aldo was not only interested in gaining consent, ideal or personal gain, he wanted that human relationship, cheerful comments, a real exchange of opinions, and also an unconventional friendship – and he nearly always got what he wanted, from the people below and above him, from clients and suppliers.

Maybe this is what allows him to win many battles together with his stubbornness and boldness: although he rarely manifested these characteristics, those who experienced them can testify just how strong, uncompromising and hard he was.

If you have ideas, you also need to know how to sell them, and then how to defend them.

Aldo had no shortage of ideas, and ideas also arrived from abroad, especially from across the Atlantic.

Chapter 17 – Irving Richards

In the year 1953, Mr Irving Richards arrived in Florence. A native New Yorker born on 18 May 1907, since 1930 owner of Richard Morgenthau & Co. which subsequently became Raymor, an American importation and distribution company.
As it so happened, an idea had developed inside Richards' head.
One should not look for items of beauty for the mere sake of selling them but acquaintances and relationships should be developed with people that become so strong that you ask and propose such items, and if the person before you is the right person, they will give you such a strong answer and such a convincing product that all you need to do is take it to America and display it in the shop windows, and people will buy it, making you rich.
It was rather a complex idea but Irving Richards had already experimented it many years before with the American designer Russel Wright, and many others.
That is because he was like an antenna, he understood taste he could feel the evolution in lifestyles, and in the end he was able to predict which shapes, colours and objects would have entered more easily into American homes. At the end, the name Raymor was synonymous in the United States for beauty, good taste and design, and on his yellow sales label, it read: *Raymor modern in the tradition of good taste.*
In short, Richards came to Montelupo and toured around a few factories, but he was not someone to buy on impulse but wanted to find a strong partnership, a solid collaboration that could produce shapes and colours that he "felt" necessary for the American market.
He entered Bitossi and met Aldo Londi.
They spoke the same language.
It was not only English that's helped them to understand each other but the way they observed the things around them that it

are changing and to the way they guessed in which direction they were headed.

They had a long chat, shared a few laughs, and strived to understand each other's intentions.

From the bag he always took around with him, Richards pulled out some pages he had torn out of American magazines articles with photographs and coloured paper napkins. He showed them to Aldo who observed them carefully and commented. He then took a notebook and, as he spoke, drew a few sketches and shapes.

Richards looked at the sketch looked up towards Aldo and smiled. And Aldo said:

- *How many pieces Mr. Richards?*

It may not have been that simple, but this is basically what happened.

In the early 50s work was like this: orders were placed by attaching pieces of paper with drawings and colour references, because the world needed ideas, it was hungry for new shapes and needed to invent a totally original type of beauty, and anyone who needed these went to all lengths to find objects that symbolised this new life that was taking shape amidst the debris left by the war.

It was a sort of revenge against barbarism, and with his curious nature, his talent, the knowledge and sheer creativity that he unleashed in his work, Aldo was the very embodiment of this revenge, of this retaliation of life against death and peace against war.

He was often heard saying – *in this world, nothing is invented,* but then various unprecedented and original things came out of his pencil.

His designs had a certain primitive and archaic aura: they were also inspired by classic or ancestral art.

They were also somewhat rough and simple, however, with an artistic touch that made them appeal to all.

Perhaps the secret lay in removing anything complicated from a design, not to leave any sketch but to leave it rather rough and get to the essential, pure and simple structure.

It had to be pure enough to understand, easy to do and beautiful to see.

Indeed there was a constant arrival of the new workers, the famous farmers who were abandoning the countryside and if you want them to learn their wage, you have to make them become ceramists very quickly.

This secret consisted in taking water, air, earth and fire, all things that cost very little, and making beautiful objects that are simple to make and produce by the thousand, and sell for very little.

In its own way, Industrial Design was already taking shape in Montelupo.

Chapter 18 – A changing Country

Also Montelupo was changing.
Council houses were being built along the Pesa river, and even in the town centre was changing, being rebuilt, reconverted and brought back to life with dozens of shops and cafeterias.
It was a new phase in which, even without Internet and mobile phones, people were getting rid of a certain provincial attitude and gaining knowledge about the new world that was developing, also thanks to the television sets that garage people around them in the evenings inside the bars.
The ceramics produced in Montelupo were now being exported in large quantities. First and foremost this brought in money – which was welcome in view of the rather catastrophic and sluggish economy – but also new tastes and traditions from faraway, which to many seemed exotic but would in time "educate" the aesthetic sensitivity of this small town.
A new middle class had been born that was wealthy and well-educated, sent their children to the nearby universities of Florence and Pisa, and built themselves find homes. These homes were furnished with a taste and brimming with products "Made in Montelupo", but also imported items, and objects and furniture that represented a new lifestyle, especially certain ultra-modern objects from Scandinavia that were quire revolutionary for Montelupo.
This widespread pride was also felt by the simple labourers, who saw the result of the work they had done the day before packaged ready to be shipped to Dusseldorf, Lausanne, New York, Helsinki or Toronto.
However, it was not all the easy sailing.
They all worked a lot even ten or twelve hours a day, often they worked Saturdays and sometimes even Sundays, and it was common to see men carrying basket of fruit tied to the back of their bicycles, or calling barrows full of small ceramic items to be

finished off at home and then taken to be fired the following day.
In garages and workshops, the woman also worked nights to produce handles and other pieces by hand. They were paid by the piece and without any employment contract, but the money they earned was needed, firstly to help to make ends meet at home, and also in the factories.

There was a great deal to be done in Montelupo, and everyone did their part.

On Sunday mornings, Aldo would often be seen going to the far end of the kiln to see how certain experiments had come out.

Thanks to the paint factory and his close relationship with the chemical experts, from who he was constantly asking for different glazes and transparent frits, it had become a sort of magical ritual and a morning liturgy: he would wear a white overall, standing next to the kiln worker on duty, and try to scrutinise, in the light of the nearest window (the kilns are inside dark rooms, poorly lit only with neon lights), the colour rendering, the shade, transparency, and how far the glaze had penetrated into the graffito.

Sometimes he would moan and get angry, other times he would go away satisfied, with his test piece in his hand and always with a cigarette in his mouth.

Chapter 19 – Life outside the factory

He would then go home, eat with his family, and then leave for Florence to see his friends in the Pananti Gallery, or the Santa Croce gallery, where painters would hand out – because he was also a painter.

He had never stopped pursuing this hobby but he was also more than a painter.

Firstly it was his way of relaxing, of recharging his batteries and getting rid of the toxins that a challenging job of responsibility gave him.

It was also a game for him, but a serious one.

He always considers himself an amateur and never sold one painting. In fact, when his friends at the "Ghibellino" Art Club in Empoli organized a charity exhibition he brought along painting for which he asked an exorbitant price.

It was his way of taking it back home and perhaps, he would put some 10,000 lire into the collection box in any case.

He was generous and definitely wasn't a miser, but he was certainly jealous of his possessions.

Although he was a good painter, he had never really had a go or painted anything for the purpose of making money and did it for his own satisfaction.

At most he might give one of his paintings to a nephew or niece for a wedding present, with an important dedication and beautifully gift-wrapped, but one can be certain that it cost him a great deal to part with his work of art.

Painting, was thus his passion but not his work.

His work was all about ceramics, it was the thing that allowed him to express himself to the greatest level, not only inside the factory.

Mr Canneri, the owner of the Cinema Teatro Risorti, asked him a favour.

He had to renovate the building and wanted Aldo to think up a

way of covering the central pillar that stood in the hallway next to the ticket office.

He created a *bas-relief* in ceramic, full of theatrical masks and musical instruments, an allegory of theatre as he understands it: brightly coloured and cheerful, a beautiful interplay of different proportions and colours.

It was huge, with a width of about one metre and perhaps two and a half metres tall, and although it was almost bi-dimensional, the objects depicted almost seemed to jump out at the observer.

That pillar represented the inventiveness the enthusiasm and the *joie de vivre* of Aldo of Montelupo, and of Italy at that time.

He gave another *bas-relief* with a still life motif, coloured with frits but smaller, to Irving Richards in 1954.

This was his creative way of being a friend, of recognising the value of those around him, of consolidating relationships and also experimenting with ceramics.

Frits are in fact a sort of coloured glass that serve to make ceramics shiny. If they are poured in a large quantity on a flat surface, such as a *bas-relief* or a plate, or even an ash tray, when they are fired they melt, forming a thick transparent layer, a shallow 'lake' that reveals the colour or the design on the bottom and which – depending on the materials and the temperature – can remain as it is or form a beautiful *craquelé* (cracked) effect.

Chapter 20 – The arrival of Ettore Sottsass

In short, it was a very fertile period, full of experiments and inventions, and also satisfaction.
Things were going well with Richard: he brought photographs and articles, tablecloths and trimmings, books and magazines about American traditional costumes to Montelupo, which he discussed with Aldo and which led to many series which were then to become part of the history of the Ceramiche Bitossi factory throughout the world, to this very day.
However, Richards was also obsessed with the idea of designers. He was always on the lookout for new talents not as a patron but as a true businessman who understands that the world asks for new living styles, and was willing to richly rewarded anyone who could offer him these are models.
He had heard about a certain Ettore Sottsass, a younger architect from Milan of Austrian descent, who had not yet found his precise location but who's works so far showed a strong personality.
He met him and convinced him to try, and one day he took him to the Bitossi factory in Montelupo.
It was 1955. Aldo was 44, Ettore was 38, and amongst other things they were both mature men.
The former had been professionally trained and was a pragmatic and creative director in a factory that was expanding rapidly. The latter was a pure artist with no idea of ceramics but eager to find his way, very determined and willing to work hard, albeit a little unsure of how to go about it.
So, they were immature but perhaps something else which may well have been the mechanism that led to that encounter.
They shared an almost childish curiosity, a creative sense of life and a desire to "play" with materials and emotions, with the people and objects, and with their eyes and hands.

That's what they were: two children in the bodies of two adult men who had already been tried and tested on everything life has to offer (they had both been at war and had been prisoners), yet they both still harboured a greater desire to venture into the world, to try and change and provoke it with a new shapes and colours, and see what effects it had.

They also shared an incredible artistic culture, a deep knowledge of the history of art and a capacity of formal vision that was second to none.

They trusted in each other like children in play, and it worked.

Perhaps at the beginning, it was mostly talk, because they both had a good communication skills and were good at exchanging that intentions and feelings without fear and without hiding anything from each other in a sly way.

Perhaps the respect between them was there from the start because Aldo recognised in Sottsass an incredible innocent capacity and a great desire to understand, and Ettore new that with Aldo, ceramic would no longer have hidden any secrets from him: if it was technically possible, anything would have been done. In addition, they were both skilled at drawing which is the best language that two designers can you use to work together.

They both produced their ideas on paper with plans, sketches, drafts, colour schemes and cross-sections, so basically more or less precise plans of any changes that would have been made when they actually worked on a project.

At the beginning, Sottsass was quite amazed at how a pigment, that was applied on a vase in its "raw" state was totally different when it came out of the kiln, and Aldo certainly didn't hide his own amazement at certain new, bold proposals that until then had been unthinkable.

They were both the mirror image of the innocence, the desires and the specific skills of the other.

In a nutshell, a friendship blossomed between two people who were very different, who used the polite form of address for each

other their whole life long, and who also cares deeply for each other until they lived.

Richards' plan had worked, but only partly.

He had guessed right: Sottsass would become a great designer, also in the world of ceramics but not exactly in the way he wanted. Aldo formed a selected pool of workers, which consisted in a potter and an artist, both top in their specific field, who were willing to carry out tests and experiments with them.

This foursome, namely Ettore Sottsass, Aldo Londi, Aurelio Giacomelli and Ugo Calonaci met to work together on Saturdays until late in the evening and although Sundays: for years this team was behind the Bitossi ceramics with the label Ettore Sottsass Jr.

All the above obtained the blessing of the Bitossi brothers who, let us not forget, paid for the glazes and frits, the clay and the firing, plus the overtime for Ugo and Aurelio.

If all these tests had led to nothing that was good enough to be sold, they would have wasted a lot of money, and Aldo would have dropped down a rung or two.

Chapter 21 – A new home and family

In the mid-fifties, Montelupo was at the height of its expansion. The factories were getting larger, hiring workers and investing, and new houses, new districts and new land parcels were needed.
One of these up was located Via Nuova, the road that leads to *La Ginestra*, between the Pesa river and that strange, very steep hill known as *Le Grotte*.
It was full of fields and vineyards – a little steep and good bricklaying skills were needed, but the price was good and Aldo went for it.
He bought a vineyard measuring 2.5 acres on which he dreamed of building his own house.
On his workbench, the thousands of pots of colour and his paintbrushes, he also had sheets of paper.
There were notes, drawings, drafts and sketches, phone numbers and anything else you can think of.
One day, Sottsass arrived and found him with one of these notes in his hand about to make some corrections.
On the paper there was a house, with trees in front and porch. It was a simple drawing, somewhat private and sentimental.
The conversation might have gone something like this:
- *Good morning Aldo, what are you drawing?*
- *Good morning Architect, well, I'm trying to draw my home. I've bought a bit of land just outside town and I'd like to build a house there.*
- *Would you mind letting me see the land? If you don't mind, I'd like to give you a few suggestions. Of course it you don't like them, it doesn't matter.*
- *I'd be honoured, Architect, if it's okay with you we can go there tomorrow at lunchtime, and you can tell me what you think.*
So, they saw the lands with the vineyards and the trees at the end of each row and decided that the popular trees should remain where they were to provide shade in the summer and that also the vines should be kept to continue producing grapes for these wine harvest in autumn.

At the time, Ettore was still not the famous architect he was destined to become, but Aldo knew that his friends was a real genius, and that he would have designed the home he had dreamt of, to which he could escape, draw, and stay with his family – even though he did not yet have any children, and with the numerous friends and relatives of their respective families (Londi and Lelli).

That is how one day a simple but accurate design was made with the measurements of the spaces and the details of the materials, from wood to stone, from the reinforced concrete of the actual structure to be bricks laid in between.

Perhaps not in front of the architect, but we are sure that in their small rented apartment in the town centre Aldo and Iolanda shed tears of joy when they saw the drawings for the most beautiful house they could ever have imagined.

Naturally, they were only drawings. Proper execution plans had to be developed and presented at the competent office at the town hall, and for this purpose, their neighbour, Marco Marconcini was involved, who took over the management of the building project, while for the actual construction, the builder Raffaello Gabbrielli, alias *Guitto*, was engaged, the father of Piero, Aldo's brother-in-law as he had married Silvanno Lelli, Iolanda's younger sister.

The house was large and very beautiful. The couple did not have a great deal of money and it was built on a shoestring and paid for with many bills of exchange which were then referred to in Montelupo as "farfalle" (literally: butterflies) and were the real current money of the day.

Not a single Sunday went by when the newlyweds did not go to check on the progress being made and choose the right stones for the walls among the "pillore" stones found along the Pesa, and set any broken pieces of wood and bricks to one side.

In the meantime, Iolanda became pregnant and she was happy because she wanted a large family and Aldo too was over the moon.

They both came from large families, they were building a large house, so they had to think about filling it with the children.
Unfortunately, Iolanda then lost Ilaria (it was a little girl), due to the fact that she was Rh negative while Also was Rh positive, and at the time this put both the new mother and the new-born child at risk.
They did not lose heart and after a short while they were again expecting a child.
This time too, things went badly: Marco was stillborn for the same problem.
We can only imagine the pain, the sadness, and the desperation of Iolanda and Aldo, who continued to see nephews and nieces being born in both their respective and large families, without being able to have a child themselves.
Piero and Silvana, who lived in via della Chiesa just a few houses away from them went to visit them with their little girl, Lina, Anna and Aldo who lived below them had Vincenzo and Maria Grazia, and then there were the Bitossi family with Guido, Genny, Maria and Monica, and the Masonis with Pietro, Giovanni, Paolo and Laura, and then Alfio with Mariella and Giuseppe, and Aroldo with Silva and Andrea, and many others, brothers and sisters, all with children.
After the war, that was the darkest period.
Their life project continued, work was going well, they did not have much money but it was enough to pay the bills. All they were missing was a purpose for all the hard work that life demanded. They missed having a child, or rather lots of children, as they would have liked.
They did not give up however. They went to speak with Dr. Granata and decided to risk once more.
That is how Luca was born in May 1957, in Florence. He was born by caesarian section, which was not a simple operation at the time.

When Iolanda saw the child, who was alive but blue due to problems during birth, she said he was ugly.

Her mother, Emma Lelli, a woman with a bold character (almost more so than her daughter), did not hesitate to give her a slap in the face, so hard that she made her lips bleed.

Luca spent his first week of life in an incubator, at the Meyer hospital in Florence. Then, once the normal conditions had been re-established, mother and child (and grandmother) returned home.

To give just an example on the date of this happy event, a telegram was sent from New York, welcoming the child of Aldo and Iolanda.

It was from Gladys and Cesar Goodfriend, two American Jewish importers who were regular clients of Bitossi.

Another one arrived from Milan, from Ettore Sottsass Jr. and Fernanda Pivano.

In fact, Aldo's clients were not only clients, but many were truly friends of the family, people he could invite to his house and spend Christmas together, and do the same things together that one would do with any relative.

A few months later, in autumn of the same year, Raffaello "Guitto" Gabbrielli (who from then on was called "Granpa Guitto") handed them the keys of their home in via Galilei, and the three of them moved in, but before long they were a family of four.

After just over one year, Marco was born. It was Christmas Day of 1958, and he was also born by caesarian section.

Iolanda would have liked to have more children, but Dr. Granata strongly advised against it. She had already been very lucky, but any further births would have put her own health at risk as well as that of any babies.

They had to be content with two children and they did just this. Aldo was over the moon: he had a fine home, a beautiful wife

(and with a strong in character to match at least his own), and two children.

The house also had central heating which was not something to be taken for granted in the 50s. It had a large stove that ran on coal or wood. The stove had to be fed and the ash had to be removed. There was also a hot water boiler for the radiators that were in every room.

The fence was rather rudimentary a source of chicken wire and the gates was also rather haphazard, made with offcuts from the sawmill in the usual fencing. Everything else was there however. There was a large field in front which lead this stones removing to turn it into a garden they and bring back some large stones known as "pillore" in a wheelbarrow: these were needed to delimit the axis road, which had spaces on either side that would one day become flower beds.

To the left of the gate between two trees, Aldo wanted two cypress trees, one of which was planted by his father, Sebastiano, shortly before he died.

That recently built home started to fill up with things of sentimental value, namely friendship, family, creativity, future, beauty, plans, hope and emotion.

Only in the first few years Aldo also looked after the vines, harvested the grapes and tried to produce his own wine, but no-one ever tasted the result of his attempt, that was perhaps an experiment more than anything.

Sottsass had been a genius however, even when he was not yet a famous architect, and made a tailor-made suit for a man he knew intimately.

This was the beginning of the Londi family home, a bungalow, with a slightly raised front part, divided into two: a large porch to the left with a cement structure for growing a lilac bush and create some shade for the summer, and to the right, a huge wall in wood and glass, that was suspended in the air because a garage was planned to be built below. As they did not have the money,

however, that magnificent wall in wood ended with a sort of French window that opened out into nothing.

Inside the rooms for all linked together: the entrance hall, a dining room, living room and kitchen where are all part of a functional circuit where you could cook, eat, talk, smoke (at that time almost everyone smoked), and in general stay together.

And with those large south facing French windows light filled every room, so much that in the spring with the doors and windows open it seems as if you were outside and the house and porch (subsequently with the patio above the garage) under the garden seemed to form a single space in which you felt you were outside when you were inside, and vice versa.

It was truly a fine example of organic architecture, a home in contact with nature, which surrounded and protected the people inside, at the same time giving them well-being and freedom.

It had a beautiful stone walls and lots of white washed walls that were very soon covered with paintings.

Chapter 22 – The first trips abroad and other stories

In the meantime, work in Montelupo and at Bitossi was going ahead like a steam train, or perhaps one should say like a plane, because at that time flights were starting to connect Rome and Milan with the main European and world capitals.

Aldo started to travel. He would go with Marcello or Vittoriano to visit clients in northern Europe and also in the US, and took the opportunity to visit great exhibitions and museums. He also met with other ceramists, especially from Sweden and Finland, and always came back home loaded with catalogues and books, ceramics and other objects, *abat-jours*, floor lamps and toys for his children.

Eight now had a large house to fill with his things, a place with which he could identify and to which he could invite friends such as Sottsass and his wife, Fernanda Pivano, the famous writer and translator, or the Goodfriends, with their son Luigi (to whom they had deliberately given an Italian name).

Luigi Goodfriend would one day become a famous surgeon, head surgeon in a clinic in Palo Alto, California, where a few years later, aided by Roberto Olivetti, Sottsass was hospitalised when he needed treatment for a serious illness.

As the saying goings, the world is small, and the world of Aldo Londi began to rotate around him, around the Bitossi factory and around his home.

For him there was no difference between public and private life, between home and work, business and friendship, art and family, and with his own particular way of seeing life, he was able to live life as he wanted, intense, rewarding and intriguing, getting everyone near to him involved.

The factory was expanding and hiring more staff, potters, artists, kiln operators, warehouse staff and office staff, and the collections were also on the rise, including more and more "Made

in Londi" items and the modern style began to slowly take over from the various classic reproductions of bygone days, with an increased presence in the orders, in the shipments, in the turnover and in exports.

He did not boast, however, but simply plodded on with his highly pragmatic method, very empirical but extremely productive.

He arrived shortly before eight every day, took off his coat and put on his "cappa bianca" (white dustcoat).

That was the term he used to describe the long white jacket, a bit like the one worn by doctors, which he regularly dirtied with pigments or when he rubbed against something or, very often, by putting his biro into his breast pocket (he had many as well as pencils and various coloured crayons, especially bi-colour pens with red and blue ink).

Then, when he went to the mouth of the kiln to see some of his test pieces come out, the heat would melt the ink, with the result that his "cappe bianche" were no longer white in the area of the left chest, but had a bluish, blackish or reddish hue, depending on the pen that had leaked ink.

Another thing that was never missing from his pockets were his cigarettes.

We do not know the exact date on which he started, but Aldo smoked from a young age and also in great quantity, as in many photographs he had a cigarette either in his mouth or between his fingers.

He smoked 'Nazionali Esportazione' without filters, in a green packet, which he lit with matches in a swift gesture, sometimes putting the used match back inside the box.

He had his own, very personal way of doing things.

He lost many things, from cigarettes and matches, from ballpoint pens to the sheets of paper containing notes which you put inside his pocket and his wife Iolanda sometimes washed by mistake. In other words his behaviour could seem a little erratic and confusional at times but he had his own logic.

Then he would look for anything he was missing, swearing, and retracing his steps until he found the missing item.
Otherwise in the case of matches he would ask the closest painter or potter at that moment to give him a light.
To smoke less, he would smoke half a cigarette then put the stub in his pocket, with the result that his pockets sometimes became an ashtray.
He was never sloppy however, not at all.
He was a very clean and neat person (he had taken after his father Sebastian, quite a *dandy* for his time). He arrived at any appointments punctually, he paid attention to the people in front of him, but cigarettes his biro and notes were his weak point.
We all have one.
Also his character betrayed him at times.
He did not get angry easily but when it did happen, there was no warning.
He spoke his mind without thinking of the consequences, and if he felt attacked or offended, or if he disliked certain things, he would attack with all the might and vehemence he could muster.
He did so in very central and civil areas, without showing his rage physically or any extremism whatsoever.
He only needed words and knew how to use them very well.
He was a sincere person, very direct and honest: if he was fond of you he showed it in any way possible, if you bothers him, sooner or later you would realise it.
As happened when Sottsass and "La Nanda" Pivano came to Bitossi in Montelupo, together with Allen Ginsberg, the great poet of the American Beat Generation.
Aldo had no prejudice with regards to all scruffy clothes, he was game for a joke but very serious when I came to work.
When Ginsberg asked if he could try and make him some golden roof tiles for his new home in America, Aldo nodded, he had no doubts on the idea which was presented before mutual friends, both the great architect who might have designed his home and

his wife, the writer who had translated Ginsberg's work and made it well-known in Italy.

Aldo made a roof tile glazed in gold, which he then took to Ginsberg, but was not pleased when he realised that it was only a weird idea – or joke – of a poet who was probably under the effects of drugs.

He did not say anything, but did not like it.

This did not lessen any way his affection for Sottsass, which was totally mutual, and their desire to spend some time together.

He had understood that that architect was a real genius. It was clear from his drawings and plans but also from the worlds and sentences he said, and from the modesty and kindness of Ettore when he approached a new but extremely fascinating material such as ceramic.

Secretly he knew that that ceramic, which until then had been destined for the production of useful items such as plates, soup dishes or umbrella stands, could have great potential of expression, it could become art, that pure art he had always loved. They both knew that by working together, my by mixing their experiences and sensitivity, their expressive power and possibilities, would have left a mark on that material, earning it a place in the Story of Humanity.

This was thus how they spent Saturdays and Sunday mornings doing a tests with "l'Ugo" and "l'Aurelio" (in Milan dialect with the article preceeding the names), and then they went back to the house of Aldo, drawn by Ettore, with a bag full of lights, furniture and ceramics, and they stayed together with Nanda and Iolanda.

Sottsass would take photos of the children with his inseparable Leica, and for his first Communion, he gave Luca his first camera, complete with flashbulb.

Just as any normal friend would have done.

This is how many ceramic products came to exist, which are still produced by Bitossi to this day, after fifty or more years, but

when you look at them it seems like they were designed yesterday, because they were conjured up within a friendship and harmony.

They succeeded: today, Ceramic products are not only plates in which to eat or vases for flowers, or containers for cigarettes, or umbrellas, but also art, and represent a nicer and more complex way of expressing oneself.

Some of the merit also goes to these two men (plus Ugo and Aurelio).

Chapter 23 – The museum, cars, and other things

The story behind the museum.
Aldo and Ettore always had a great deal of respect for each other, also in their friendship. Together with Iolanda and Fernanda, *or La Nanda*, they would often go for a drive in the hills around Montelupo and sometimes stopped to eat in a local *trattoria*. Like all folk from Milan, Ettore loved Tuscany and its food.
In so doing, the idea was born to search for some land, possibly some woodland, that they could buy with the idea of building a museum.
The idea of the museum was still vague. They wanted a place where Pivano what have being able to bring all her archives, and Sottsass and Aldo what have gathered together the finest ceramic from around the world that could find, naturally including their own.
It was a fantastic idea and they also found just the place, in the hills south of Montelupo, towards a place called Bottinaccio.
They fell in love with it, they dreamt and is talked about it continuously because that was the place that was to represent them. There was also an outdoor space where they could put large monumental objects and installations, and indoor space where would they build up the most beautiful collection that had ever been seen.
Sottsass also took a few measurements. He created a few 3D models made a few sketches of how he saw the new Museum.
The beauty that each of them found, in their own particular way, in the things they made or saw in the world, would now have home, a place where they could be conserved, cherished, and made public.
And they were creating that place.
It was not to be, however.

They tried to involve their friends, industrialists, and the town hall, but it was all in vain: the projects were blocked and the dream ended forever.

That was how, in Montelupo, the opportunity was lost to have a very modern and unusual museum that could have glorified the History of Ceramics and much more, from the very beginning to the present day.

One misses a train either because you are late, or you get there too early.

In the meantime, work went ahead. There were other journeys and the life of Aldo also went on.

After Luca and Marco were born (and after he had finished paying the bills of exchange to Raffaello "Guitto" Gabbrielli), he decided the family deserved a car, and bought a beautiful Black Fiat 1100 from a priest who had regretted buying it. It was basically new. It had the gear shift lever on the steering wheel and the seats were still covered in cellophane.

That is how Chiodo's relationship with cars first started, and it was always one of love and hate.

His brother-in-law, Marcello was a great car lover, of Porsche cars in particular, and the ceramic medallion given to him by Aldo, with a bas-relief of the legendary 911 and a "butterfly", the same image that appeared on a coin used as legal tender in Italy at the time, was quite famous. Despite their friendship, Also was not a brilliant driver, in fact he was only a modest driver.

He had no accidents but he drove very badly, and while he was fascinated by the mechanics over the car in itself and by its design in particular, he had no idea of the mechanical principles and techniques of better driving.

His cars lasted a long time, however, at least 10 years, which is meant that he was at least a careful driver

He did not like changing his cars and perhaps he could not afford to, either.

He prefers to spend his money on paintings, on art magazines, books and also ceramics.

That's right: as if he did not have enough with his own ceramics, he bought other pieces from around the world, from his friends and colleagues, and also a few antique pieces when he found them at a reasonable price.

Anyhow, he did not drive well, he was a distracted driver, but still very careful and respectful of the rules, so he only got a few fines. Following the black Fiat 1100 which he bought from the priest, as his children were growing older he to a white Fiat 1300. It was also second-hand but in perfect condition and he bought it from Scotti in Empoli, again advised by his expert brother-in-law, Marcello.

It was a totally different car, definitely more modern and faster, with a light blue and grey interior colour lots of chrome-plated moulded parts and large upholstered seats.

All his cars covered a very short distance, to the factory and back four times a day, sometimes he went to Bobolino to see Nanni (Giovanni Londi, a well-known pig breeder and butcher, in addition to a very warm-hearted relative), and to buy a few sausages, to Empoli or Florence, to his brothers and sisters, in addition to going to the usual exhibitions and art galleries.

If he went to there with Marcello, obviously Marcello would drive and they would go in the Porsche.

In 1966, he then bought a home by the sea.

It wasn't exactly by the sea but about twelve kilometres from Marina di Cecina, inland between Guardistallo and Montescudaio. It was a sort of *kibbutz*, an estate that looked towards the coast from the hill on which it stood. It had just under 10 acres of land a large farmhouse, in which the ex-POWs of Zonderwater had built twelve very basic bed-sit flats, each with their own garage below.

It was his "buen ritiro", or his retreat, without any electricity or drinking water, where he met up with his old companions of misfortune.

He spent his summer holidays there in August with his family, and on occasions he would go there at weekends, taking the state road 67 up to the 'Arnaccio', from where he took the State Road 206 up to Cecina.

It was a 60-mile journey but it took him over two hours and his children often got carsick, also thanks to the road bends that their father whizzed around at full speed.

That is when he decided to change car, and he bought a dark green Fiat 124 Sport.

It was truly a sports car, a two-door cabriolet with anatomic seals in brown fake leather, while the steering wheel and floor-mounted gear lever were in shiny wood.

He has not bought it for speed, however, quite simply his old 1300 was too old and he fell in love with the design of that modern, sporty and fast automobile.

He drove this car in the same way he had always driven all his cars: calmly and absentmindedly.

It was not a great purchase, however.

Naturally everyone including the children loved that car. both Iolanda and Aldo were comfortable, the large windows opened wide so they could both smoke in peace.

The problem was the rear of the car, the rigid structure, the difficult access from the rear doors and two venting quarter windows that let only a small amount of air in, together with the fact that both the children suffered from car sickness.

Especially when they went to the sea, if they did the road that went through Volterra, that was full of bends, they had to stop three of four times to let them breathe (or vomit).

Furthermore, what he still insisted on calling children were growing at an impressive speed and were becoming real "little Maremman boars", their legs were getting long and their knees

now pushed against the seat in front, so they were uncomfortable, crouched and squashed.

In short, the beautiful design of that car came at rather a high price for all.

Also the 124 Sport was changed only due to evident problems of wear and tear.

At that point Aldo had learned his lesson, and bought the car that had been used by his sister Anna, from his brother-in-law Marco (naturally at a discounted price).

It was a safe buy for a used car, which had a very low mileage, and it was also the finest car that Chiodo had ever driven.

A blue Peugeot 504 with metallic finish, and electric fuel injection, 225 HP: even it had only 4 gears, it was as lightning, and like all French saloon cars, it reached 110 miles per hour.

Aldo never went that fast, that his children did (he never found out).

That was the car that took him into his old age, and he never consumed it to the end like he did with the previous cars.

That car would cover hundreds of miles more, he did not.

However, he did have its repainted – this time in white – to cover up a number of scratches that were made when manoeuvring the car through the gate or into the garage at home.

He did not have a good aim, and I'll see his reflexes wasn't that big car could be dangerous.

He swapped it for a Citroen Visa, and adorable yet rather frail car which dilapidated quickly, and had to make way for a Ford Fiesta, his last car.

He did his very best to destroy this car, too. Now an old man, he continued to go to the sea by himself, forgot where he had parked it, and as he did not have a good eye for distances, he spent more money on bodywork than on petrol.

The Ford outlived him, however, confirming the value of the brand.

Chapter 24 – La Serena, friendship

Let us return to the house by the sea or *La Serena*, as it was called by the cooperative of ex POWs, which looked out towards the sea from the inland of Cecina.

This was the place where he had found his old fellow prisoners once again, people with whom he could exchange memories and who now bore his same scars.

He went there often together with his family, and from 1966 onwards he spent all his August holidays there.

They would go to the seaside in Marina di Bibbona, Bagno La Pineta dagli Zazzeri, where the children would play in the sea, Iolanda would read a magazine under the sun umbrella and he would chat with his former comrades-in-arms.

Between a dip in the sea and a cigarette, he got to know Franco Gentilini, a famous painter born in Faenza but who had made Rome his new home, who also went to the Zazzeri bathing establishment and had a house in the countryside near to Guardistallo.

It was a wonderful and lasting friendship, made of gifts and kind gestures, visits and great discussions, always highly respectful however as Gentilini was the Maestro when it came to painting.

Just a few hundred yards further down from La Serena, Gianfranco Carlevaro took a summer home.

He was born in the nearby town of Vada but had studied Opthalmology in Parma and had gone to work in Milan where he had become a luminary.

He had then gone back to his homeland and had bought this tiny house with lots of land all around and had made it into what he called his *Porziuncola*, or his own little refuge when he was free of work.

He was also a poet and had a truly fine style of writing. He published books of poetry and perhaps, from looking after the eyes of others he had changed his own vision of the world.

Aldo's friendship with Carlevaro was an explosion of activities and serious, important discussions, long walks in the countryside in August, and also tiring games.

In fact, despite their age, Aldo and Gianfranco were two children who had invented a game.

The game was not exactly childish and consisted in renting out a large bulldozer, driving around the property and collecting huge stones that they then deposited in a field near to the house.

Then, when they thought the assortment of boulders was sufficient, date sorted them out based on size and shape and, using the bulldozer (manoeuvred by an expert) driver would build enormous monsters, and enormous men lying down on the grass, and fantastic animals, all somewhere in between five and ten metres in length, made up of boulders that weighed as much as several tons.

The lawn in front of Carlevaro's *Porziuncola* had become a museum of fantasy, expressed in awesome dimensions.

Here were two people who are expressed joy, creativity, their carefree attitude and their energy, who would then meet up again in the evenings, exhausted but happy, and would contemplate their crazy efforts holding a glass of wine.

It was a wonderful way you spend the summer holidays, at least for them.

The friendship with Gianfranco Carlevaro between was very strong, it was a case of two people finding their 'soul mate' in adulthood, and they grew old together playing like children.

One book would not be sufficient to talk of Aldo and his friendships.

He was not an easy man, at times it was difficult to like him, but it was very easy for him to be found of people.

He had always had a strong character from being very little, but he was also loving and kind with that old type of politeness that was based on respect.

He had a very different character and education, he was distant from the children's games but also from the strict rules in the Londi household.

His family always came first, and his love for them was absolute and powerful and made him become a point of reference and a guide for all his family, first for his brothers and sisters, then for his in-laws, nephews and nieces.

Then there were his friends, from his school pals to the first curious young boys who discovered arts together with him.

Bruno Bagnoli, Benvenuto Staderini, Beppe Serafine, and then Ganino and Tosco Cianchi, and slowly the whole town, which was a solid place from which he had never distanced himself.

Then there were his comrades-in-arms: people he had got to know during the war or in prison, and he became a friend to all of them.

Chiodo even became friends of the "enemies", and we can be sure that at the end, he and colonel Prisloo were also fond of each other.

Then he came back home, and work led him to meet hundreds of clients, colleagues and suppliers.

He kept in contact with everyone he befriended, even without Internet and e-mail.

He did not like to use the phone, which he refused to have installed in his own home for many years with the excuse that *anyone who really wants me will ring the bell*.

He wrote, and received, many letters, from every part of Italy and the world.

His home was like a sea port, with Iolanda always ready to welcome guests, with the coffee pot and liqueur glasses always ready, when they did not all have lunch together at home.

They had hundreds of friends, all of whom were very dear to them, then there were the special friends.

Marcello Bitossi, Rino Grazzini, Mario "Cecco" Bellucci, Marcello Posarelli and others, in whose cheerful company they enjoyed memorable trips out and dinners together.

Another brother-in-law to who he was very attached was Piero Gabbrielli, the husband of Silvana Lelli, Iolanda's younger sister, who was also the son of Raffaello "Guitto" Gabbrielli, the one who built his house in via Galilei.

He was also very fond of Aldo Viviani, the husband of the elder sister, Anna Lelli. They had all been tenants in the same house in the centre of Montelupo, but with Piero and Silvana they had a very close relationship, mainly because both the sisters had children of basically the same age, so the two families would often go out together to let their children "graze".

Among the clients, there were Gladys and Cesar Goodfriend, who often came to Florence (they even bought a house in the centre), and they never came without making a trip to the Londi home, where they would smother the children with presents and Iolanda with kind words, with the typical kindness of the old Jews of New York.

There was a sort of annual ritual when the height of the children was measured in a room containing samples of the ceramic selection. Cesar would gather Luca, Marco and their little cousin Monica (the youngest child of Marcello), and mark their heights on the wall in a corner of the room, always pleased to see how the children had grown.

Then there was Mr. Izzat Zamrik, from Damascus, a rather fat Syrian who was always cheerful and came laden with jams and Arabian sweet delicacies and sumptuous garments for Iolanda, who always thank him but never wore them.

Mr Rosenthal of Rosenthal Netter was another major American importer.

There were also Germans, Scandinavians, English (only very few).

Although he had known them all through work, he always invited home the people he liked most and they became part of the family.

Maria Lind, for example, a Finnish ceramist he had met in Helsinki on one of his various trips to North Europe, without counting Sottsass and Pivano, who often came to Montelupo.

In short, for Aldo, friendship, affection, and time spent together was like a lifeblood that made him strong, whether he was at home or travelling around the world.

He was always pleased to return to the factory, however, because for him that was the most beautiful place on earth.

The family, the factory and his town gave him the energy he needed to go on and to win his wars.

Chapter 25 – South Africa and Japan

He was always pleased to travel such as when he returned to South Africa together with Vittoriano Bitossi in 1967 (for him it was like a homecoming).
For Aldo, who was now used to air travel and the long intercontinental flights, that was perhaps "the journeys of all journeys".
There, he met up with many old fellow prisoners, such as the sculptor, Edoardo Villa, his eternal friend Quattrocecere, Colombo, and many more.
This time he went as a tourist, however, and it visited Kruger Park, Cape Town and Johannesburg.
Then together with his friends in South Africa, he went back to visit Zonderwater.
It was a source of pilgrimage to the place where he had suffered most in life, where he had seen many friends die, where he had learnt to hate war and love freedom.
He came back from that's journey rather shaken but happy, exhausted yet strong. It had been a sort of reconciliation with a land where he suffered so much he almost died, but which he always considered his second homeland.
Indeed, he had spent five years of the harshest life imaginable right there, and they too had to have a meaning and some sort of value for him.
From Zonderwater, tucked neatly away in his suitcase, he brought back some pieces of barbed wire and a toilet lid, a piece of rusted iron that he then used as a gong when he organized there his great banquets among friends at La Serena.
It was not easy to see Aldo cry, but when upon returning home, he opened the suitcase I'm showed those objects to Iolanda, he was overcome with emotion and he cried like a child.
War has a high price, but you also have to you own peace.

Then, together with his brother-in-law Marcello, he left with a delegation of small companies (Piccola Industria) to the Expo of Osaka in 1970.

We can imagine that in those years, the Orient what's truly an exotic destination, and the journey took him to Hong Kong, Bangkok, and finally Japan: the cradle of tradition, the last empire of the East, and at the same time the home of electronics ophthalmology and precision engineering. In other words it was the home of all the most sophisticated types of technology that were displayed side-by-side at the Expo. It was like making a journey around the world, through the various eras of human History, in just a few days.

In Hong Kong, you took advantage of the tax free prices and bought a Japanese camera, a Yashica with a semi-automatic range finder, with which he used ten of rolls of film to take shots of everything, from the floating market of Bangkok, to the antique Shintoist temples of Kyoto and the skyscrapers of Tokyo.

Ten rolls of film and 360 photographs, of which his photographer friend Fumagalli printed only those in which it was possible to discern anything, only around ninety, of which some were beautiful but others were fancy or out of focus.

Chiodo was fascinated by new technology but is at times this feeling was not mutual and it made him angry.

He was a man who used his brain and his hands, words and actions, but was not at all skills with ferrules, washers and numbers.

However, he came back in love with Japanese art, raku ceramics and the museums and buildings made of wood, which told the story of that antique civilisation.

Chapter 26 – Galezzo Cora

Aldo was obsessed with history, in particular the history of ceramics and he never abandoned the idea of setting up a museum in Montelupo.

This idea was encouraged even more through his friendship with Galeazzo Cora, a scholar and a collector of antique ceramic objects, in particular those made in Italy.

He descended from an old, noble family and had dedicated his entire life to collecting, cataloguing and studying from around Italy.

Londi was able to contact him through mutual acquaintances, and in his numerous visits to Florence he appreciated both the man himself, perhaps the greatest expert in the field, and his endless collection that he had accumulated throughout his life as a shrewd connoisseur and lover of ceramics.

His huge home was crammed full of hundreds or thousands of masterpieces, and due to a lack of space not everything was on display.

Aldo spoke of nine large rooms full of chests that were crammed with ceramics.

He then had the idea to persuade Cora to donate everything to Montelupo.

It was a hard battle, because at that time there were no tourist attractions in Montelupo, while Faenza already had its own Museo della Ceramica with a history of collections and collaboration that went back to 1908, and which was renovated after being totally destroyed by bombs in 1944, and boasted an international network of donations, collaborators and consultants. Chiodo fight hard battles, however, and tried in every way possible to persuade Cora to donate his collection to Montelupo.

Unfortunately, passion was not enough: credentials when required alongside plans and guarantees that could not be found, so Cora donated everything to Faenza.

The ceramic Museum of Montelupo (Museo della Ceramica) was finally set up, thanks to the discover of the Pozzo dei Lavatoi (washing well) and to the dedication of many ceramists, such as Coli and Aldo Londi himself. However, instead of travelling a mere 16 and a half miles to reach Montelupo, thousands of magnificent relics dating from medieval times to the nineteenth century, which came from all over Italy and had been exported around the Mediterranean from Florence, were taken on a journey of over 60 miles, across the Apennines to Faenza, where they still add prestige to the MIC (International Museum of Ceramics) to this day.

For Aldo, this was a huge disappointment and the second, if one thinks of the Museum he wanted to create together with Sottsass and Pivano.

In short, Chiodo was not lucky with museums.

Perhaps it was important to be good at politics and to make complex weaves made of acquaintanceships, alliances and vague promises.

He was not a good politician, he did not make promises that he could not keep, and as for sewing skills, he was very good at undoing the pockets of the white overalls he wore at work, nothing more.

Chapter 27 – Art before everything

The meantime, the years went by everybody and also for him.
He did not give up, however, even if his hair started to go white before he was 50. He did not feel old and he wasn't.
He continued to produce ceramics, to sell then and to paint and to experiment with new techniques.
He made ceramic sculptures, made using large slabs that he then scored and cut using iron wires, the same ones used for cutting lumps of clay. He covered them with iron grids, which left strange imprints and the coloured everything using metal-effect, iridescent and strong pigments.
He discovered a product called Alubit: an extremely hard substances that was used by Bitossi to produce grinding systems. As it was an extremely compact powder that had to be fired to become as hard as quartz, but was not exactly as plastic and pliable as the clay he used, he scored and engraved it, using it to create geometric bas-reliefs that he called "Machines to raise ideas".
He was always active and tireless, he was a real mine of ideas and felt free to create and constantly tried to do so.
Freedom was what he cherished most.
After the war and imprisonment, the gunfire, deaths, hunger, and the bombings, waking up in the morning with a desire to do something, to produce, to create something new was his way of thanking the world for the period of peace and tranquillity he was now living in.
Freedom did not go beyond duty, however, and also in this respect he was an example for all, both in the factory and at home. He was stubborn, the type of person who did not easily bow down two rules that he did not like. He was strict firstly with himself, then with others.

In family, he was a moral authority. They called him the "Ayatollah uncle Aldo", his brothers, sisters and everyone in their families adored him and respected him as the undisputed chief of the Londi tribe. There was no dispute or mischief for which he was not called to judge the matter with his wisdom and firmness.

At the factory, always on the usual subject of "value", seeing how his drawings were transformed into ceramics, which in turn were transformed into orders, into turnover and ultimately work, money, employment and well-being for all, he was well considered and respected by everyone, from owners to the cleaning lady, as an artist, director, and a ceramist who knew how to do his job.

He was loved by many and envied by some, others feared him, but he did not have many enemies.

There were naturally some epic instances of competition between "equals" in the factory, and Chiodo did not shy away. He was a true lion, just like his star sign *Leo*.

Then however, he would go back to his large home, relax, potter around the garden, read his magazines, the fair catalogues, and paint.

He painted country landscapes or still life motifs. He had built himself a workshop behind the house, leaning against the old hut rebuilt with bricks. It may have been left behind by the farmers who worked in the fields.

There was a great deal of chaos in that workshop with piles of newspapers, magazines, books, parts of the dried up paint, tubes, boxes, paintbrushes, clay modelling accessories, and screwdrivers: a fantastic world of toys that helped him to distance himself from the rest of life.

When he painted, unlike when creating with ceramic or pliable materials, he did not strive to create a modern look, minimalist designs or pure symbolism.

He was an extremely good classic painter yet not at all obsessed with originality and the sophisticated looks that others craved for.

He liked going to see and also participate in exhibitions, but not as a competitor. On the contrary, he was well aware of being an almost amateur painter who was pleased with his work but had no great aspirations.

With ceramics it was a different matter: he took part in a great number of national and international exhibitions, but that was his job. He had to keep the reputation of Bitossi on a high level and had to face a very vast world from which he could gain inspiration and learn something, and compare himself against it.

He also travelled a great deal whenever possible.

In the 50s and 60s, when attending ceramics tradeshows and dimensions together with Marcello, he never missed the opportunity to visit all of Europe, in particular Germany and Scandinavian countries, where modern aesthetic culture was even more developed.

He also visited galleries and museums in these countries, got to know colleagues and clients, consolidated relationships, and came back laden with books, catalogues and pieces of ceramic.

He also never failed to bring a gift for his "little children".

In those years, Bitossi sold a great deal in the Scandinavian countries, which were then the homeland of the design: the Raphaelesque period was part of history by then.

He could never get enough of History, Art and Culture.

He also had some wonderful conversations with Vittorio Alderighi Ceccato, an interpreter and friend of the Bitossi family who lived in Florence, a noble of Russian descent, whose family had fled from Saint Petersburg in 1917 due to the revolution.

Ceccato was called by Vittoriano Bitossi to lay the foundations of the new Export Department, a structure that had become necessary due to the increasingly intense relations with representatives, suppliers and clients throughout the world.

He was a tall, slim man with a highly sophisticated way of talking and addressing. He spoke about fifteen languages correctly, was extremely affable, friendly and was fond of Aldo.

Few people had the same intelligence, sophistication, sensitivity, and knowledge of art as Ceccato.
They talked about churches and museums, and seemed like two cousins who were talking about their relatives and their own homes.
They knew all the works exhibited in museums such as the Prado, the Victoria and Albert, the Hermitage, the Vatican museums and the Guggenheim, without counting the Uffizi and others.
Hearing their conversations, one could imagine being there in those very rooms or standing below the domes, admiring the paintings and sculptures, *bas-reliefs* and sinopers.
They were not trying to show off their culture or knowledge but simply enjoyed a sincere exchange of emotions, passion, and the thrill they felt for beautiful objects that they passed on to each other, and which triggered a series of memories and sensations and fascinating ideas that made them feel as happy as two children.
Aldo was curious, and if he met someone similar to him, he was always pleased. He accumulated that curiosity, that thrill for beauty and that love for art inside him, he elaborated these thoughts to develop his own highly sophisticated aesthetic culture. He distilled it and translated it into simple shapes and colours that were pure and modern, but if you observed them closely, it was clear that they had all started off with a long and complicated process.
This is what kept him alive, dynamic and observant even through the hardest moments of life.

Chapter 28 – Retirement

One of these hard times for Aldo was surely when he retired, especially the economic boom of the 50s and 60s was followed by the petrol crisis in the 70s, and the world and relaxed a little: certain values questions and the volume of work also dropped considerably.
These were difficult years also for Chiodo, who saw "his" factory slowing reducing the numbers of staff, without finding a replacement for those who retired.
Of the almost 180 people who were hired during the boom, only 100 people were left in the ceramic sector, while the number of paint factories continued to expand at global level, and his Flavia (as he called it) became the Cinderella of the Bitossi Group.
He retired officially in May 1976, but never stopped going to the factory, where he would develop new lines of products, adding new items and maintain relationships with the company's historic clients and his friends.
He was 65 years old and had been making ceramic items for fifty-four years, but he did not feel old – he never felt old.
He had a lot of free time and spent it by transforming his home into an experimental laboratory.
He drew sketches and worked out new decorations, using his old Ford Fiesta as a shuttle between his home and the kilns in Samminiatello, where he had his test pieces fired.
Everyone at the factory loved him, from Vittoriano Bitossi to the most recently hired kiln worker, up they had a tremendous respect for someone who had earned this respect as a Patriarch, not only as head of his family but also for the value gained on-site, as if a whole load of medals were pinned onto that white overall (which he still wore at the factory), any anyone who saw him would click their heels together and perform the military salute.

He might have got on some people's nerves and others might have resented him interfering with a production cycle that was almost no longer his business, but out of politeness, or fear of him exploding with rage (this part of his character never abandoned him), no-one ever showed signs of annoyance.

He never missed out on the opportunity to travel and as soon as there was a possibility to leave, his suitcase was always ready.

Shortly after retiring, in 1976, Chiodo accepted an assignment proposed by Colorobbia, and left for Tehran, in Iran, as a consultant and trainer in the tile factory that was being built in the Kashan area, and did not miss out on the chance to visit some of the historic and artistic sites of Persia.

The most beautiful trip, however, is probably the one that he made in 1981 when he went to the Virgin Islands.

His task was that of the organising, on behalf of the king of the Florentine leather trade – Mario Bojola – a ceramic factory named "Italian Pottery": it was to have an adjoining school where young people could be trained how to produce ceramics.

We have to imagine a very curious man, slightly old but still at the height of his strength and with an almost youthful enthusiasm and optimism, who left on his own and spent three months on the island of Saint Croix, in the Virgin Islands.

It was officially part of the United States, but located in the heart of the Caribbean, where the inhabitants were a mix of the descendants of former African slaves and European settlers, in other words they form the basis of an "American"-type organisation. The pace of life is still creole, helped by the magnificent climate and sea, lush vegetation and the vocation of the place as a holiday destination. Aldo together with Luca Bojola, Mario's son, started to work organising, working and teaching, but he had to accept the slow rhythms of the locals.

He met new friends, including a certain Andrea Londi, who was not related to him in any way but works as a skipper with his catamaran in the archipelago, and in addition to working, went on

beautiful excursions in the archipelago with his new friends, both by sea and by car.

He got used to the local customs, grew a beautiful white beard that made him look a lot like Ernest Hemingway, and which showed off his dark, tanned face.

No-one, who has just retired, good organise a more interesting period for him/herself than the one that Aldo spent in the Virgin Islands.

In order not to miss out on anything, on the trip back, he made a stopover in New York where he met up with his brother-in-law Marcello and his nephew Guido Bitossi, and also went to visit his dear friends, Gladys and Cesar Goodfriend, Irving Richards of Raymor, and the Rosenthals of Rosenthal Netter.

After such a beautiful and long trip, that ends with such a grand reunion, he returned home tired but happy.

He had no time to rest, however: back home, he had friends to visit, exhibitions to see, others to organise all participating, plus sketches and designs to do, new projects to put into practice, and new ideas to accomplish.

He went on more trips, if you journeys to North Europe, then back to New York in January 1985, together with his nephew Giovanni Masoni, artistic director, and the husband of his niece Jenny Bitossi, Bruno Cei, sales director, in order to meet the people in charge at J.C. Penny, change store that has recently become a client of Flavia.

Upon their return, these two young relatives complained about that tireless and stubborn uncle who, in spite of an incredible snowstorm, walked relentlessly along the pavements of the Big Apple to reach the Guggenheim Museum rather than the MoMa, dragging the two young men behind him, who were obviously in difficulty.

In short, he liked to travel but was always pleased to go back home to Montelupo.

This was now his life and he liked it. He filled it with new things to invent, under the complacent gaze of his wife and the help of friends and colleagues.

Chapter 29 – Good news and bad

Naturally, he was getting older. This was clear as he saw his sons grow and bring their girlfriends home, or grow moustaches like all the men in the Londi family, perhaps even a beard.

In August 1981, Luca got married to Miriam Falai and they went to live in Capraia, right next to the Pasquinucci pottery factory, where he organised many exhibitions and even held exhibitions of his own work.

Then came his most devastating moment, when Iolanda died of a severe case of leukaemia on 13 August 1985.

There is no point meeting about the bush. Life always presents you with devastating moments and, especially if you have a strong sense of the family in every way as he did, these start early.

First there was the death of his father, in 1957, who was only just in time to see Luca being born, followed by that of his mother Marianna in 1976, then the early and atrocious death of his niece, Maria Bitossi, which left him stunned and angry for all his life, and now his wife.

That was, perhaps, the pinnacle from which his downfall started.

A slow but relentless downfall.

Many people were no longer around, his companions in Art, Bagnoli, Staderini, Serafini, then his cousins Cianchi, Giacco Pilade and Walter, and lots of friends, Leonida Pieraccini above all.

Throughout his life, he had never felt like a veteran, although he had good reason to.

He had survived the wars (he had fought in two!), the shootings, imprisonment, the bolts of lightning in South Africa, malaria, the hatred of the English, the range of the Boers, the German U-boats, thirst and hunger.

He had seen hundreds of his comrades-in-arms and friends die, he too had almost died, but he had returned home, regained his strength, and had continued to fight for the things he believed in.
He had always been a fighter, peaceful but a fighter, never a veteran.
His family stayed closely by side, his son Marco went to live with him in his large house, while Luca and Miriam tried to help them with everyday problems.
Always nephews nieces and relatives in general, first and foremost the Bitossi family, also did everything they could, and not a day passed by without someone calling him or inviting him, all making sure that he looked after himself.
They all still recognised him as a great Patriarch and everyone, from the friends that were left to the Directors of the factory wanted to help him to heal his wound, reduce his pain and induce him to react.
Although he never recovered from this disastrous moment, he did react in the way he knew best, with Art.
He never recovered but he was better.
He was also helped in this respect I certainly new friendships that he had established with people who were younger than him.
One of these was Marina Vignozzi Paszkowski, a scholar from Florence who would then write his "real" biography.
Then there was Betti.
Betti was the daughter of "Daini", a close collaborator of Vittoriano Bitossi and a friend of Aldo, but that has nothing to do with it.
Elisabetta Daini, whom everyone called Betti, had a petite build, with blonde hair, kind, well-mannered, respectful and very, very complicated.
She was a lover of art in all its forms, and never missed the opportunity to observe, study, understand and be involved in art, and to organise artistic events. At the end, she became such an expert (especially in ceramics), that she started to work at the

Foundation of the Museum of Montelupo, followed by the Vittoriano Bitossi Foundation.

But also this has nothing to do with it.

Betti and Chiodo were friends, which was very important.

They were real friends, they called each other then they attended exhibitions together, they exchange presents and they often went out for dinner together.

They formed an odd couple and at times mingled with friends and relatives, such as Guido Bitossi or Antonio Manzi, an artist from Lastra a Signa, or other "sprightly old men", such as Ferrero Mercanteli and his partners of Italica Ars of Signa, other times they spent time alone, like two friends who are content with each other's company.

Sometimes, in a Museum in Florence or in any art gallery, it was possible to see an old man with white, combed back hair, a huge moustache, elegantly dressed and with a sharp look in his eyes, together with a pretty, elegant young lady, as they discussed the works of art on display, or the catalogue, and how it was better or worse than the one they had seen the previous year, or other similar or different things.

Aldo often went to visit Betti at the Foundation, and at times, as he looked back through his chaotic memory yet full of fantastic experiences, he almost acted as a "historical consultant".

They formed an odd couple, as we have said, but a fine one, full of that shy and respectful affection, of that attention made of the little things that fill the heart, the soul and also the days.

Betti was, therefore, Chiodo's last great friend and she was very important to him.

He was also important to her.

He found an inner harmony in which the most important thing was his interest in beauty, a research for aesthetic perfection that was at times compulsive but creative, free, and full of imagination.

It was a fragile harmony and it was easy for him to feel alone, when you think that most of the people you have known in your life are no longer there. It's easy to feel worthless.

Then, however, he would find a different shape, a new colour, a strange combination, and he dived in head-first.

After living in their small house in Capraia for ten years, together with a couple of friends, Luca and Miriam sold it to buy a large farmhouse needing renovation in Pulignano, in the hills between Capraia and Limite. While they were renovating the farmhouse, they went to live with Aldo, while Marco, after an engagement that lasted a lifetime, went to live with his fiancée, Simona Allegranti, in a farmhouse near to Montespertoli.

By decision of his sons and daughters-in-law, Aldo would never have been left alone.

Having a woman around the house was positive for Aldo, who became very attached to his daughter-in-law.

Then finally, some good news arrived: Chiodo was going to become a grandfather.

On 3 April 1993, at the hospital in Empoli, Marco and Simona had a son, Sebastiano Londi.

That baby, with that name, was like the icing on the cake, a story that finally began to make sense, a life that found its value once more.

Aldo was so excited, and he laughed and pulled the strangest and funniest faces at that child, as grandparents normally do, as if they had lost their heads completely, doing embarrassing things that – as strict fathers – they never did with their own children.

Chiodo's lineage would have continued to trample on the world, with the name of that cattle trader, who had taught his son the value of hard work, sweat and words.

In the meantime, the house in Pulignano was ready. Luca and Miriam moved in and Marco and Simona went back to live in Aldo's house, with Sebastiano.

Aldo would never have been alone, on the contrary...

In that very house, after thirty-six years, there was a child there once again. He would have lived there with his parents and his grandfather that strange, surly grandfather who was at the same time funny and a little bit weird.
The family was back once more and, in one way or another, things worked.
Children help adults to reconstruct the future, and this is what Sebastiano did with his grandfather Aldo.
The years past and things were more or less calm. Aldo continued to use the house as laboratory, Sebastiano used it as a playground (just as his father and uncle before him), and Marco and Simona did the best to strike a balance between the two creative spirits who lived today together.
In the meantime, Aldo had found another place where he could take his mind off his everyday problems: Luca and Miriam's house in Pulignano.
He went to see them often and would stay for lunch or dinner. He would take his painting equipment with him and paint in the garden or in the countryside, and while away the time with his friends.
Then, when he felt like it, he would go to the sea – by car!
Now we know that Chiodo's had never been outstanding: just imagine a man of that age who takes his old Ford Fiesta, slightly the worse for wear, and drives sixty miles to go to his house by the sea.
All these children and relatives where utterly worried when he went on one of these impromptu outings.
Even when he went to see his relatives in Empoli, on several occasions he had forgotten where he had parked his car, and had to get everybody out to try and find it, never mind such a faraway journey!
To anyone who are expressed their worry about these risky car trips, he would reply
- *Driving relaxes me.*

There was no reply to that.
Then one day, when driving around Montelupo, he entered a one-way street in the wrong direction and was scared.
No-one said anything to him and the traffic wardens were also understanding and patient, but for him it was an alarm signal.
He understood that the moment had arrived to leave his car at home and get his children to very him around, and they were happy to take him anywhere he wanted.
He was old and he knew it, although he hid it well.
Sometimes his memory would play tricks on him, at although at times he would get a name wrong, he always managed to get away with it with his wit.
In addition, he was always busy doing something and filled his days with various commitments, at home and away, and even if he didn't have the energy he used to, after a short nap he was off again.
Then the "Full Moon" arrived.
It was 11 May 1998: Simona gave birth to Lapo Londi at the hospital in Empoli.
After many years, Chiodo was visible up Happy once more.
Sebastiano had filled his home and his life with light once more. Lapo filled them with music.
As is usually the case, he was totally different from his brother (just as his own sons, Luca and Marco were totally different). Lapo was well-behaved, calm, peaceful, and smiled at all times and to everyone.
His grandfather fill in love with him, literally.
His relationship with Sebastiano, a very vivacious child with a strong fighting spirit, was beautiful but conflictual at times, marked by that severity that Chiodo always brought out with all those that he wanted to protect in some way.
Not with Lapo. He was a who looked at you and laugh with his little round face, red cheeks and a blonde curly hair.

He gave him the nickname of "Lunapiena" (literally: full moon), which was full of beautiful, important meaning for him.
It represented the light that brightens the sky, that illuminates the past before you and helps you to find your way in the dark.
Now, Chiodo's House in via Galilei was full. Two children had come to live there, like Luca and Marco, like in the happy times with Iolanda, with Christmas lunches with the entire Londi family, and suppers with friends from all over the world.
Both children were also left-handed, like their uncle Luca, their grandfather Aldo, and perhaps many others in the Londi family before them.
Everything had even more sense, a purpose and an objective.
Ah, if only Iolanda could have seen those children!
Who knows how many times he whispered this to himself.
In the meantime, he still kept going, trying to organise in some way the huge mass of things that he had accumulated in his lifetime.
He was not used to archiving memories, however, he was a collector of beauty, a rather chaotic designer with a poor memory.
He was constantly losing his keys and often went to the hardware store to have copies made. He would go out with two bunches of keys, as he said:
- *One to be used and one to be lost.*
It was the same with books, magazines and catalogues.
He would take one, of the type he liked the most, and take it to bed with him, such as the one from the exhibition of 1991 at the Museo della Ceramica in Montelupo, in Palazzo Pretorio.
It was entitled "80 Anni 80 Pezzi" (80 Years 80 Pieces), and gave a full account of the exhibition, with a beautiful introduction by Ettore Sottsass, that he would read over and over again.
His bed was often covered with catalogues. He would browse through them before suddenly nodding off, always leaving the light on so that as soon as he woke up, even in the middle of the night, he would start reading again.

It was his way of remaining in contact with beauty, even at nighttime.

Then there were exhibitions to go and see, either in Florence with his friends or nearby, or alone.

For someone who knows how to live, life is always full of interests: and he knew, he had lived life to the full and intensely, for over ninety years.

He had had a life full of interests and appointments, full of births and deaths, wars and gatherings, illness and recovery, successes and failures: Aldo's collection of appointments was a huge book.

Then the last appointment arrived.

Chapter 30 – Ciao Chiodo

It was a rainy evening in February 2003. Aldo had gone to the Pasquinucci pottery in Capraia, to see yet another exhibition of his friends.
Upon seeing him, one of them greet him, saying:
- *Aldo, you're looking really well!*
He replied with a smile:
- *Shut up, I'll have to die healthy!*
In that sentence, Chiodo had summed up his vision of life, with his way of joking even in moments of suffering, on old age and nasty things.
He walked back home, as he was used to doing, and when he reached via Marconi, where it meets with via Galilei, he crossed over the road.
Another elderly man who was driving along via Marconi, did not see him.
He banged his head on the bumper and ended up on the ground, practically in front of his house.
He lost consciousness and was rushed to the hospital of Empoli.
He was taken into intensive care, where he died the following day.
As fit as a fiddle, as he had foretold his friend.
The life of Aldo Londi came to an end o 10 February 2003, at a stone's throw from where it had begun, ninety-one years, seven months and three days after that 4 August 1911, when the first Sebastiano Londi waited outside on the *seggiola*, while Marianna give him his first-born child.
Between those years, everything possible happed, good and bad, great pain and infinite joy, lots of disappointments and a great many satisfactions, as happens in the lives of all of us.
The life of Aldo Londi was a different life, however: it was one of those lives that is worth telling.

Acknowledgments

It is hard to make this list, forgive me if anyone has been left out.
I thank my wife Miriam Falai, who had put up with me for almost forty years and honestly I don't know how she does it.
I thank my brother Marco Londi, the true keeper of the family's history, jealous curator and mindful of Chiodo's things, and his family Simona, Sebastiano and Lapo who are like my own.
I thank my cousins Guido and Monica Bitossi who have helped me more than a little proving themselves to be more Londi then even I am.
Thanks go to Paolo Pinelli, the mind behind the Vittoriano Bitossi foundation, who has always thought that this would turn out to be a great piece of work.
I also thank Marina Vignozzi Paszkowski, a friend to Chiodo and his "true" biographer, who together with Silvia Floria created something wonderful, and I will never stop saying that.
Finally I want to thank Betti Daini my father's great friend, and a friendship that I inherited together with his most precious things, and one that is especially dear to me.
ll